CAPTAIN RUGGED

KEZIAH JONES NATIVE MAQARI

DAMIANI

This book is dedicated to the memory of Segun El-Yakubu a.k.a Joey Ducane, the original Captain Rugged.

CAPTAIN RUGGED

by Keziah Jones and Native Maqari

The reason we decided to do this graphic novel was initially simply because of a deep desire to see our home city and our home country represented in the graphic novel form. We believe Lagos to be as visually arresting as London, Paris or New York, it just happens to be arresting in a very different way. The juxtaposition of different architectures imposed by its inhabitants from different eras - from the Portuguese houses constructed by the returned slaves from Brazil, to the colonial buildings left by the British or the ultramodern and almost brutalist creations of the architects of the 70's where the capital city of our newly oil rich nation was the playground of several avant garde European architects.

At the same time we have witnessed the most transformative stories happening within and around us in the city of Lagos so it was inevitable that we both attempted to put this into words and image and sound for an outside audience in order that they might also get an idea of the character of the city.

After the oil boom years of the '70's, visually, Lagos resembled what can only be described as an unfinished African utopia; grand projects lay abandoned and subsequently taken over by the homeless, grand motorways that span the lagoons surrounding the islands of Lagos overrun by hastily constructed shanty towns on stilts. The city became both futuristic and of the past at the same time.

Our story is set amongst the teeming masses who live in these in-between places. People who came to the city hoping for a share in the riches said to be found all over, but unable to return, making do with what they have and as result, surviving against all odds.

The only protagonist that we could conceive of who was surviving on his own terms in this type of environment was a superhero. This is due to the fact of the unending harshness of the daily grind of the inhabitants. But daily grind can also be experienced as transcendence, because at the end of every day Lagosians will sit down and ease away their troubles by recounting, to whomever will listen, the numerous surprising and amazing things they have seen over a beer and some music.

For both of us the city of Lagos will never cease to amaze, therefore it was not surprising that a superhero called Captain Rugged would appear, because if we didn't invent him someone else would have.

And now that he is here we feel we have kickstarted a new version of the process created by the Nollywood phenomenon, African auto-mythology, a process by which a people start to reinterpret themselves as a tableau upon which a radical break from the past can be constructed.

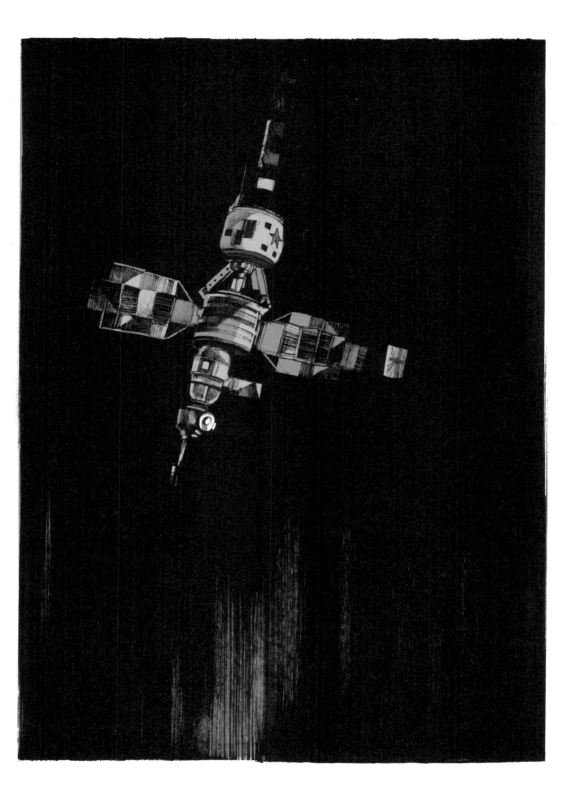

SOMEWHERE ON THE MAINLAND LAGOS

CLICK.

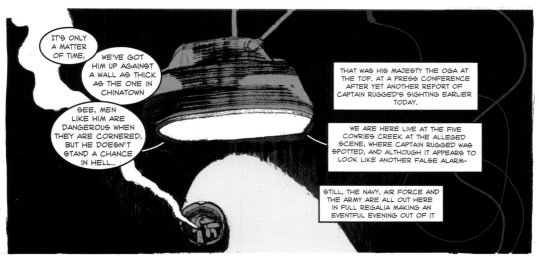

IT'S ONLY A MATTER OF TIME,

WE'VE GOT HIM UP AGAINST A WALL AS THICK AS THE ONE IN CHINATOWN

SEE, MEN LIKE HIM ARE DANGEROUS WHEN THEY ARE CORNERED, BUT HE DOESN'T STAND A CHANCE IN HELL—

THAT WAS HIS MAJESTY THE OGA AT THE TOP. AT A PRESS CONFERENCE AFTER YET ANOTHER REPORT OF CAPTAIN RUGGED'S SIGHTING EARLIER TODAY.

WE ARE HERE LIVE AT THE FIVE COWRIES CREEK AT THE ALLEGED SCENE, WHERE CAPTAIN RUGGED WAS SPOTTED, AND ALTHOUGH IT APPEARS TO LOOK LIKE ANOTHER FALSE ALARM—

STILL, THE NAVY, AIR FORCE AND THE ARMY ARE ALL OUT HERE IN FULL REGALIA MAKING AN EVENTFUL EVENING OUT OF IT

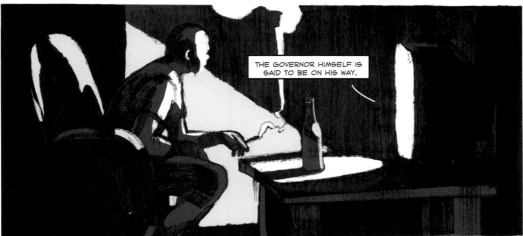

THE GOVERNOR HIMSELF IS SAID TO BE ON HIS WAY.

THIS IS EBONY FYNE FACE REPORTING FOR THE CUNNYMAN DIE CUNNYMAN BURY AM NEWS NETWORK.

WE CAUGHT UP WITH LIEUTENANT MOSQUITO OF THE MUCH FEARED WAHALA SQUADRON TO GET HIS TAKE ON CAPTAIN RUGGED—

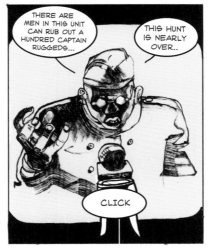

THERE ARE MEN IN THIS UNIT CAN RUB OUT A HUNDRED CAPTAIN RUGGEDS...

THIS HUNT IS NEARLY OVER..

CLICK

NA LIE!

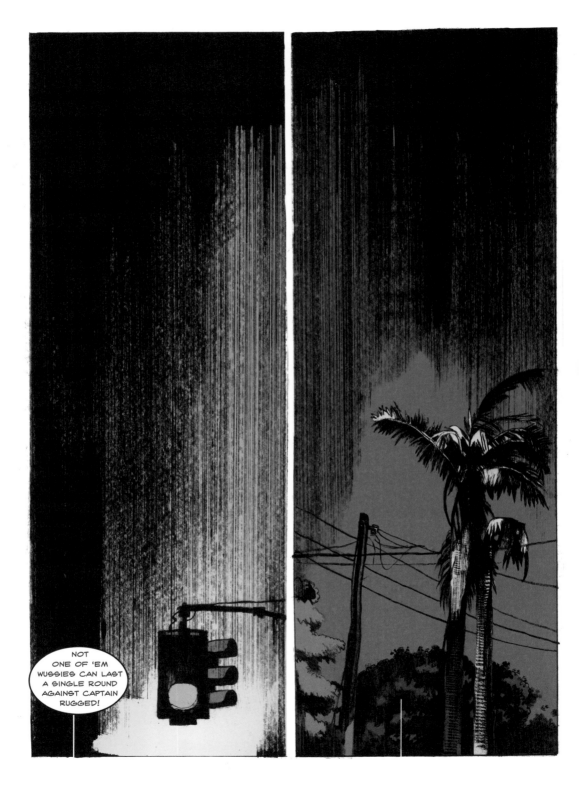

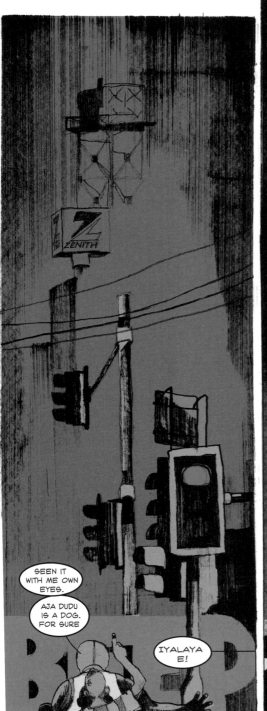
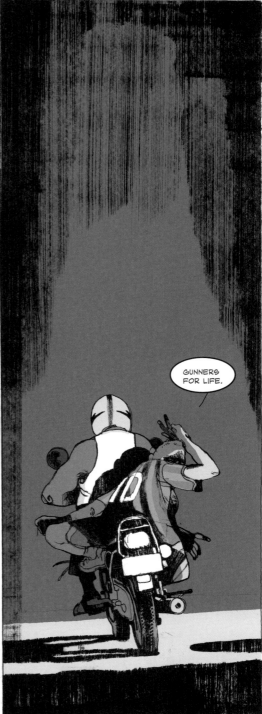

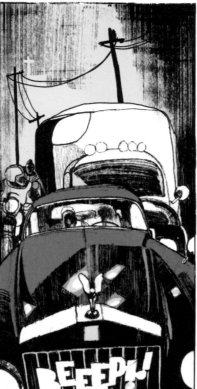

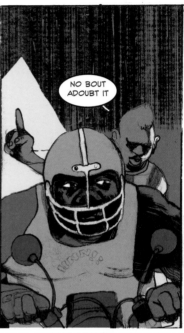

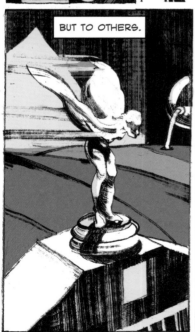

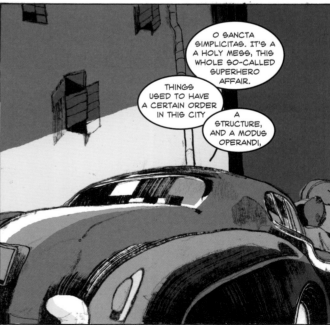

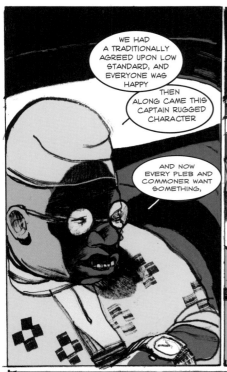

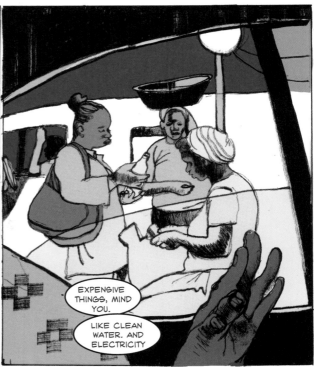

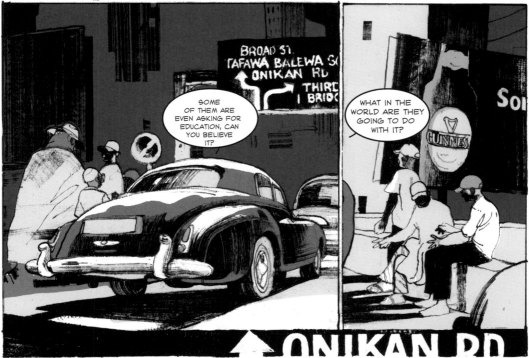

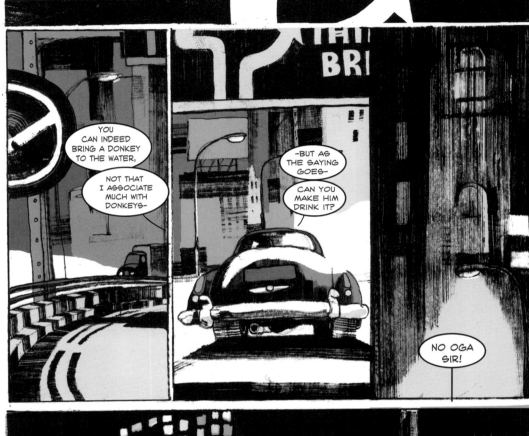

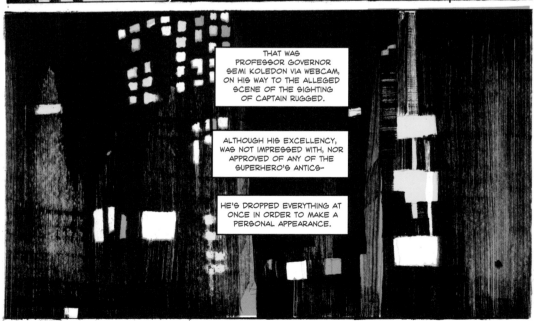

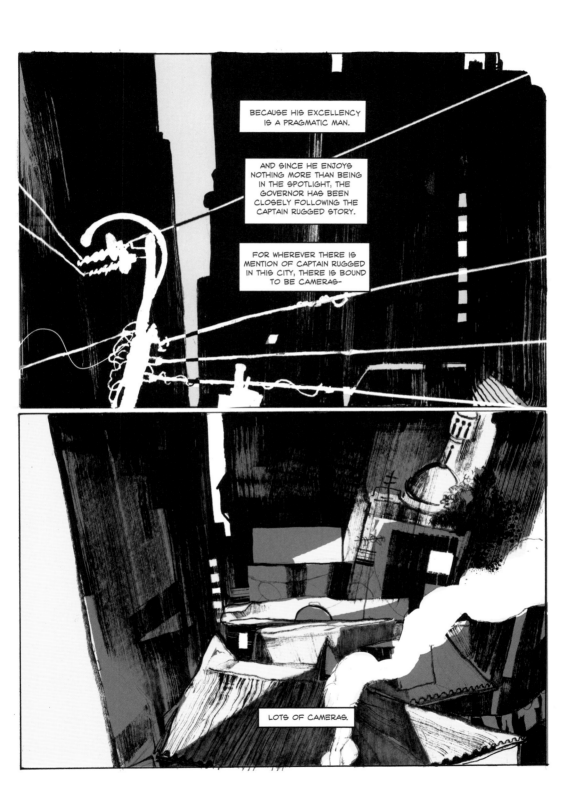

BECAUSE HIS EXCELLENCY IS A PRAGMATIC MAN.

AND SINCE HE ENJOYS NOTHING MORE THAN BEING IN THE SPOTLIGHT, THE GOVERNOR HAS BEEN CLOSELY FOLLOWING THE CAPTAIN RUGGED STORY.

FOR WHEREVER THERE IS MENTION OF CAPTAIN RUGGED IN THIS CITY, THERE IS BOUND TO BE CAMERAS—

LOTS OF CAMERAS.

BOOK I

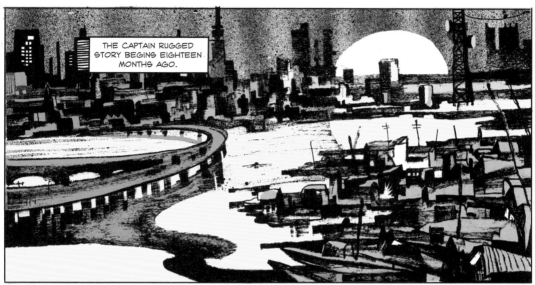

THE CAPTAIN RUGGED STORY BEGINS EIGHTEEN MONTHS AGO.

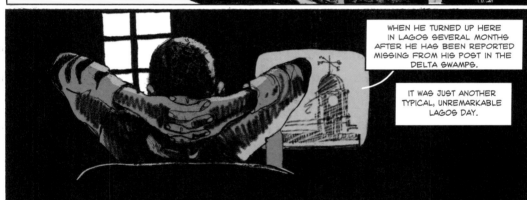

WHEN HE TURNED UP HERE IN LAGOS SEVERAL MONTHS AFTER HE HAS BEEN REPORTED MISSING FROM HIS POST IN THE DELTA SWAMPS.

IT WAS JUST ANOTHER TYPICAL, UNREMARKABLE LAGOS DAY.

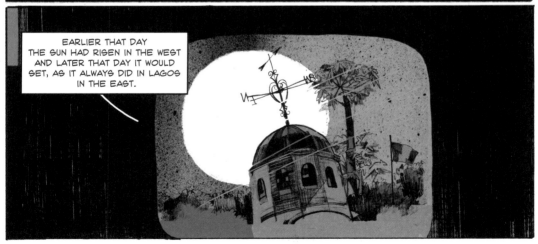

EARLIER THAT DAY THE SUN HAD RISEN IN THE WEST AND LATER THAT DAY IT WOULD SET, AS IT ALWAYS DID IN LAGOS IN THE EAST.

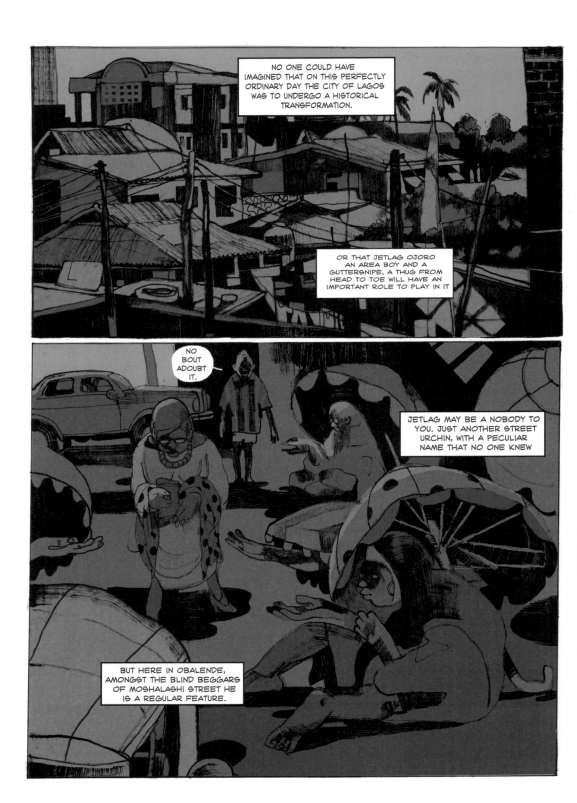

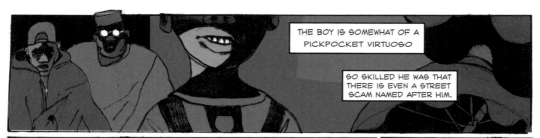

THE BOY IS SOMEWHAT OF A PICKPOCKET VIRTUOSO

SO SKILLED HE WAS THAT THERE IS EVEN A STREET SCAM NAMED AFTER HIM.

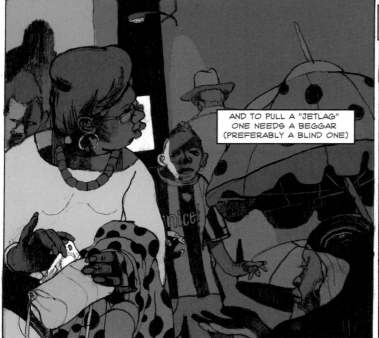

USING THEM AS BAIT TO FIND OUT WHERE THE HAPLESS MARKS KEPT THEIR MONEY.

AND TO PULL A "JETLAG" ONE NEEDS A BEGGAR (PREFERABLY A BLIND ONE)

AND THE REST—

IS MOSTLY ABOUT DISCRETION.

GODBLESS

IT'S A SIMPLE ENOUGH SYSTEM FOR ANYONE WHO DARE TRY—

LUCKY

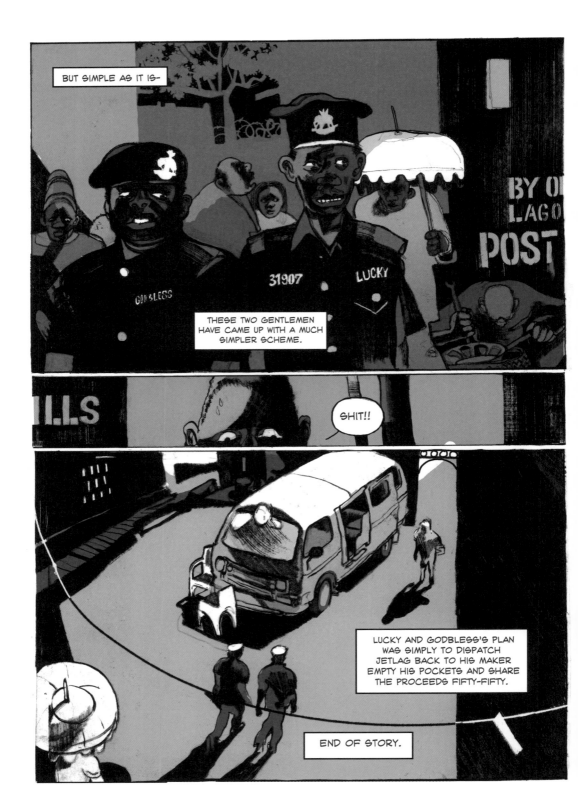

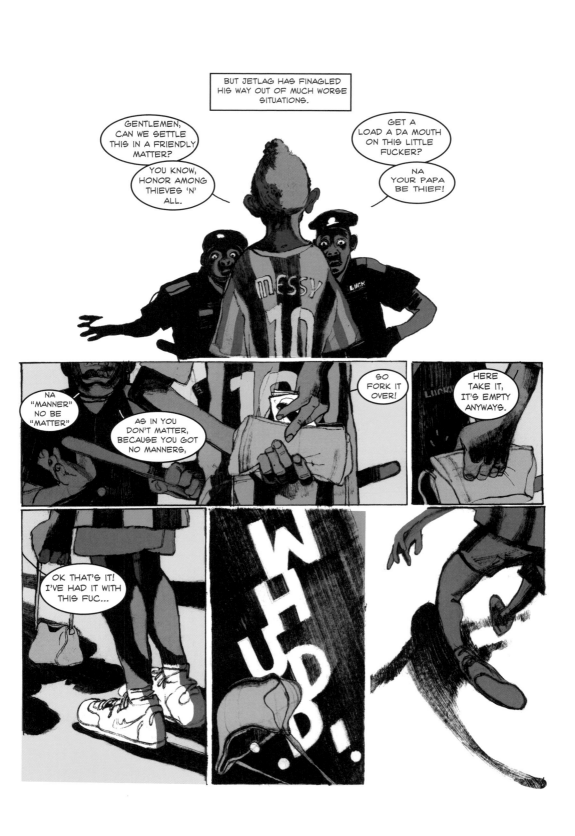

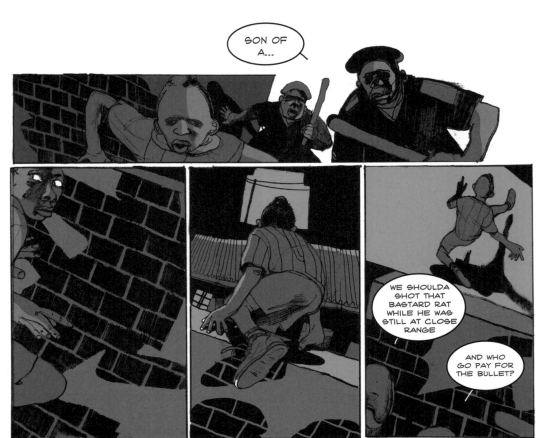

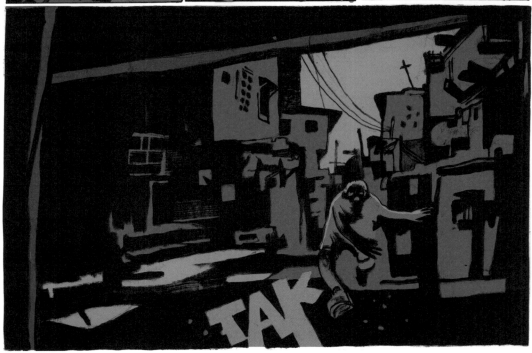

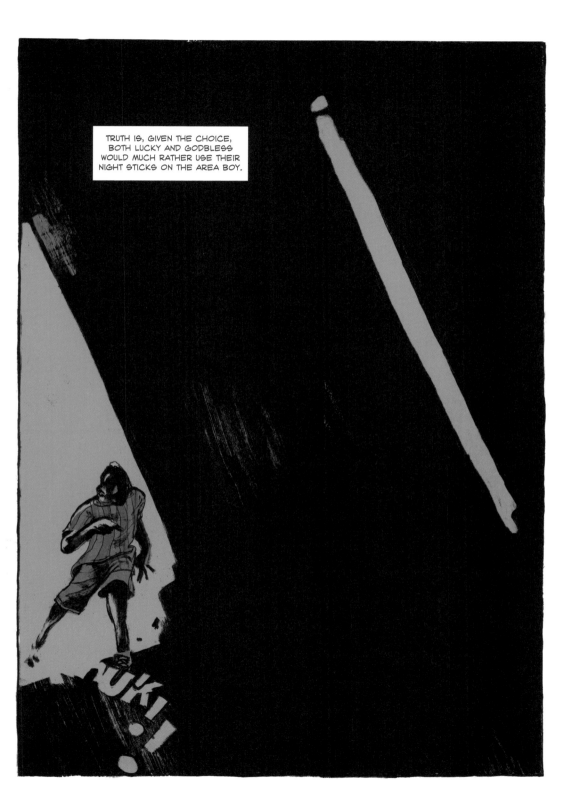

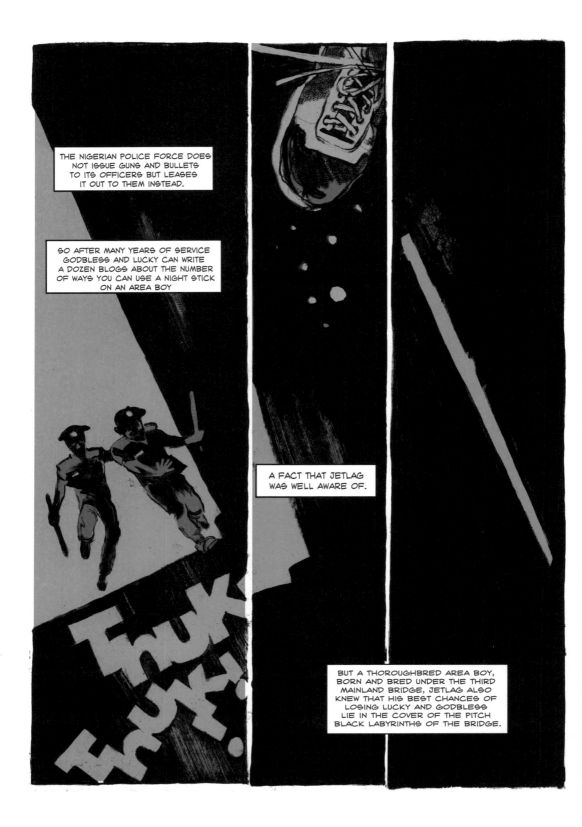

THE NIGERIAN POLICE FORCE DOES NOT ISSUE GUNS AND BULLETS TO ITS OFFICERS BUT LEASES IT OUT TO THEM INSTEAD.

SO AFTER MANY YEARS OF SERVICE GODBLESS AND LUCKY CAN WRITE A DOZEN BLOGS ABOUT THE NUMBER OF WAYS YOU CAN USE A NIGHT STICK ON AN AREA BOY

A FACT THAT JETLAG WAS WELL AWARE OF.

BUT A THOROUGHBRED AREA BOY, BORN AND BRED UNDER THE THIRD MAINLAND BRIDGE, JETLAG ALSO KNEW THAT HIS BEST CHANCES OF LOSING LUCKY AND GODBLESS LIE IN THE COVER OF THE PITCH BLACK LABYRINTHS OF THE BRIDGE.

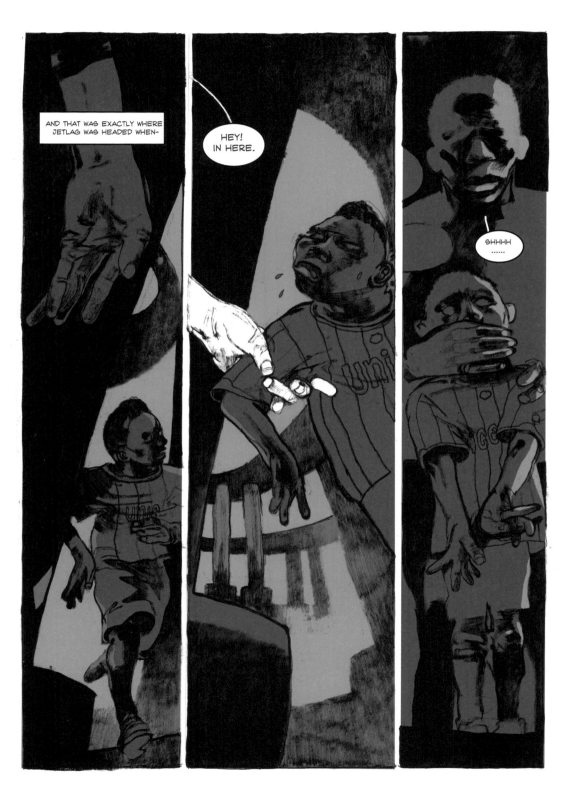

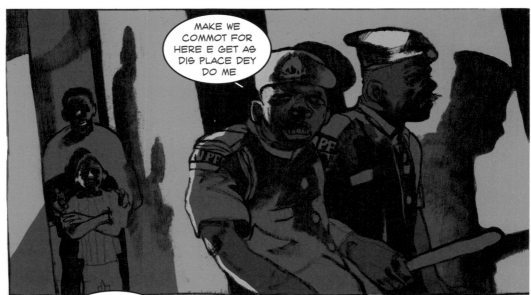

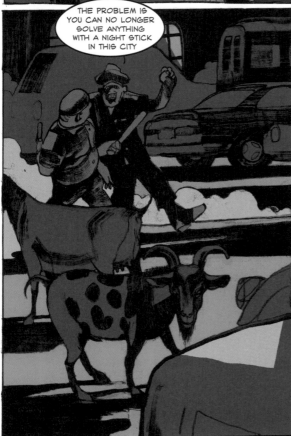

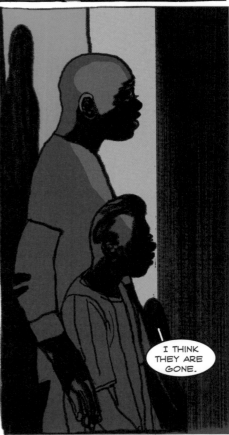

OYA, VAMOOSE.

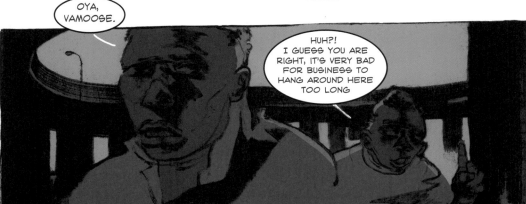

HUH?! I GUESS YOU ARE RIGHT, IT'S VERY BAD FOR BUSINESS TO HANG AROUND HERE TOO LONG

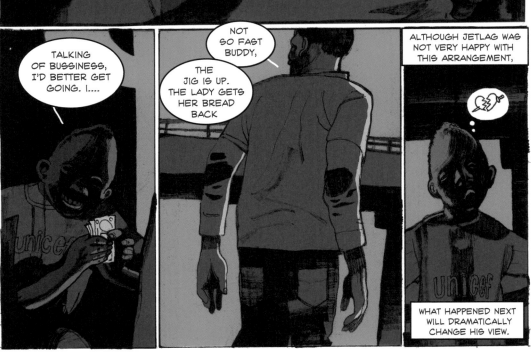

TALKING OF BUSSINESS, I'D BETTER GET GOING. I....

NOT SO FAST BUDDY,

THE JIG IS UP. THE LADY GETS HER BREAD BACK

ALTHOUGH JETLAG WAS NOT VERY HAPPY WITH THIS ARRANGEMENT,

WHAT HAPPENED NEXT WILL DRAMATICALLY CHANGE HIS VIEW.

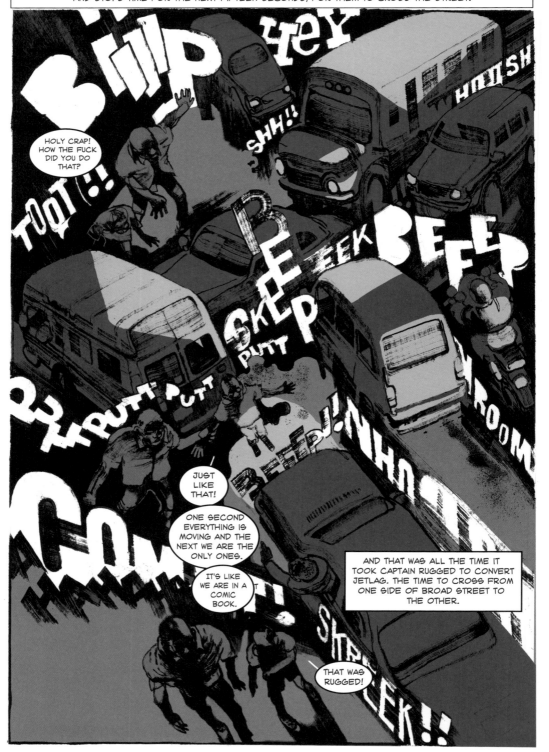

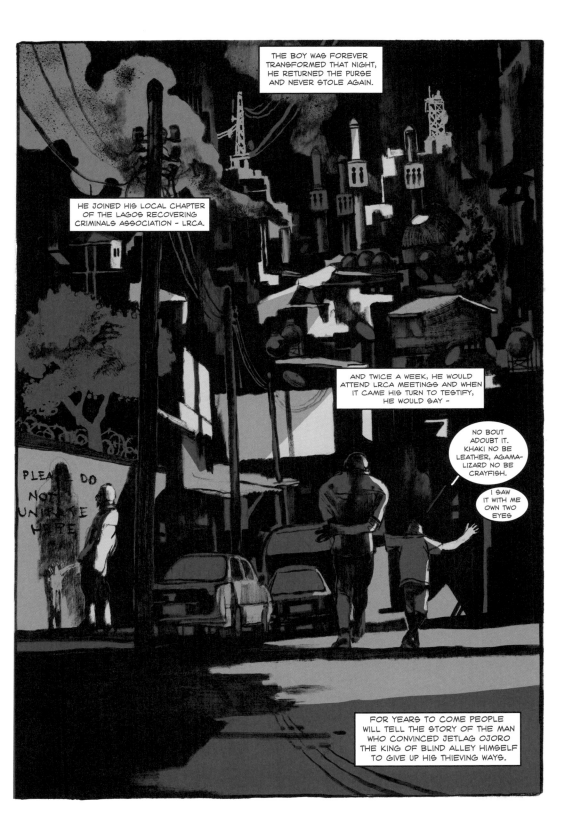

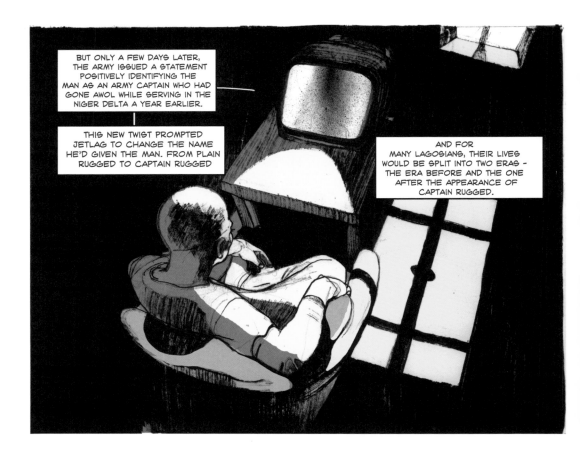

BUT ONLY A FEW DAYS LATER, THE ARMY ISSUED A STATEMENT POSITIVELY IDENTIFYING THE MAN AS AN ARMY CAPTAIN WHO HAD GONE AWOL WHILE SERVING IN THE NIGER DELTA A YEAR EARLIER.

THIS NEW TWIST PROMPTED JETLAG TO CHANGE THE NAME HE'D GIVEN THE MAN. FROM PLAIN RUGGED TO CAPTAIN RUGGED

AND FOR MANY LAGOSIANS, THEIR LIVES WOULD BE SPLIT INTO TWO ERAS - THE ERA BEFORE AND THE ONE AFTER THE APPEARANCE OF CAPTAIN RUGGED.

EVERY LAGOSIAN COULD RECALL EXACTLY WHERE THEY WERE WHEN THEY HEARD THE NEWS OF THE SUPERHERO WHO DID THE UNTHINKABLE:

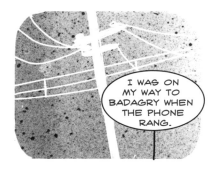

I WAS ON MY WAY TO BADAGRY WHEN THE PHONE RANG.

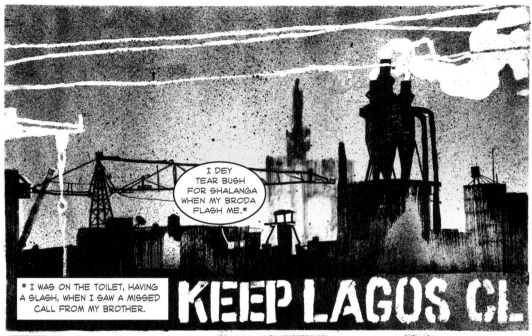

* I WAS ON THE TOILET, HAVING A SLASH, WHEN I SAW A MISSED CALL FROM MY BROTHER.

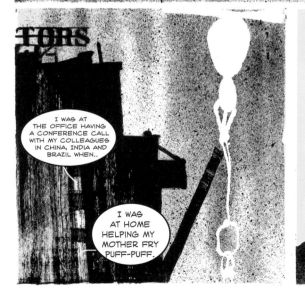

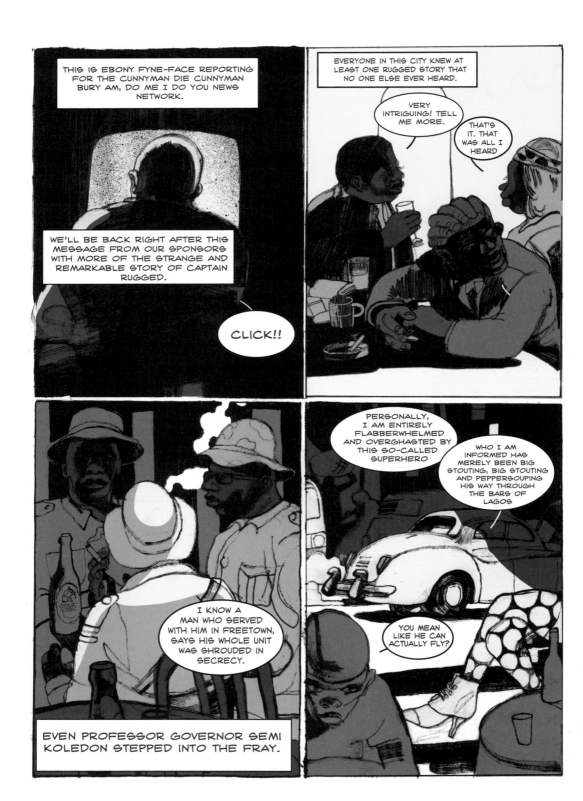

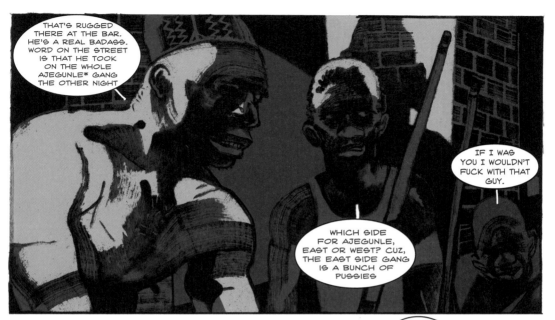

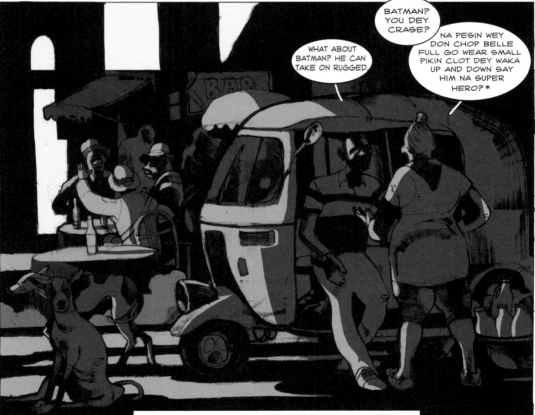

* WHAT KIND OF A PERSON IN HIS RIGHT
MIND WILL WALK AROUND IN A KID'S LEATHER
BODY SUIT AND THINK THAT HE'S A SUPER HERO

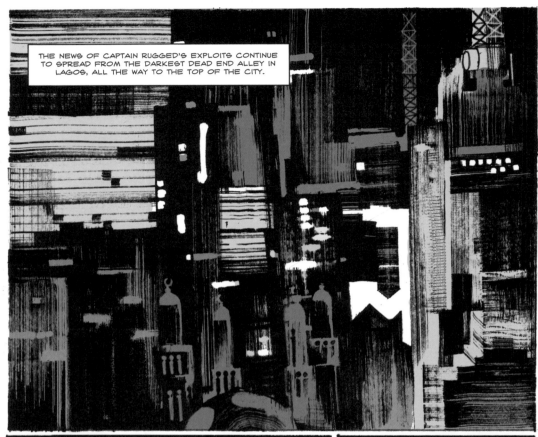

THE NEWS OF CAPTAIN RUGGED'S EXPLOITS CONTINUE TO SPREAD FROM THE DARKEST DEAD END ALLEY IN LAGOS, ALL THE WAY TO THE TOP OF THE CITY.

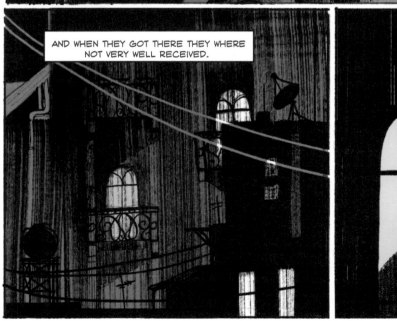

AND WHEN THEY GOT THERE THEY WHERE NOT VERY WELL RECEIVED.

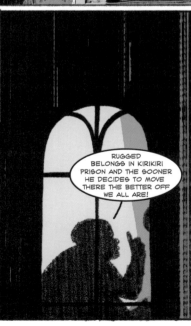

RUGGED BELONGS IN KIRIKIRI PRISON AND THE SOONER HE DECIDES TO MOVE THERE THE BETTER OFF WE ALL ARE!

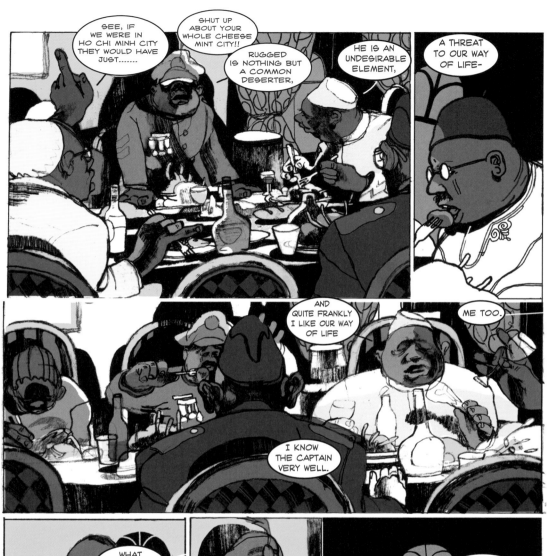

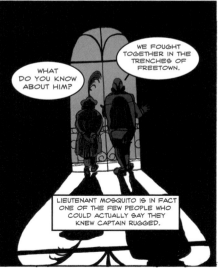

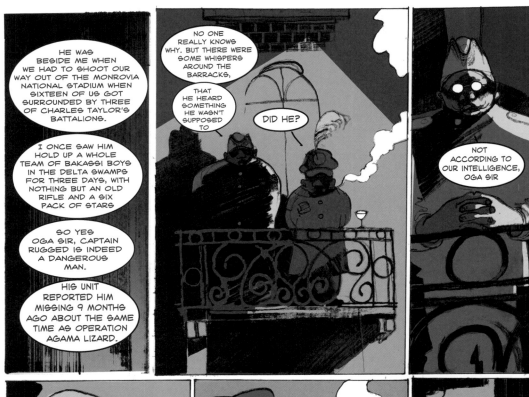

HE WAS BESIDE ME WHEN WE HAD TO SHOOT OUR WAY OUT OF THE MONROVIA NATIONAL STADIUM WHEN SIXTEEN OF US GOT SURROUNDED BY THREE OF CHARLES TAYLOR'S BATTALIONS.

I ONCE SAW HIM HOLD UP A WHOLE TEAM OF BAKASSI BOYS IN THE DELTA SWAMPS FOR THREE DAYS, WITH NOTHING BUT AN OLD RIFLE AND A SIX PACK OF STARS

SO YES OGA SIR, CAPTAIN RUGGED IS INDEED A DANGEROUS MAN.

HIS UNIT REPORTED HIM MISSING 9 MONTHS AGO ABOUT THE SAME TIME AS OPERATION AGAMA LIZARD.

NO ONE REALLY KNOWS WHY. BUT THERE WERE SOME WHISPERS AROUND THE BARRACKS,

THAT HE HEARD SOMETHING HE WASN'T SUPPOSED TO

DID HE?

NOT ACCORDING TO OUR INTELLIGENCE, OGA SIR

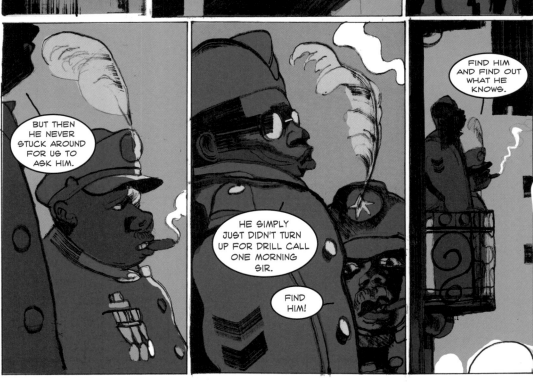

BUT THEN HE NEVER STUCK AROUND FOR US TO ASK HIM.

HE SIMPLY JUST DIDN'T TURN UP FOR DRILL CALL ONE MORNING SIR.

FIND HIM!

FIND HIM AND FIND OUT WHAT HE KNOWS.

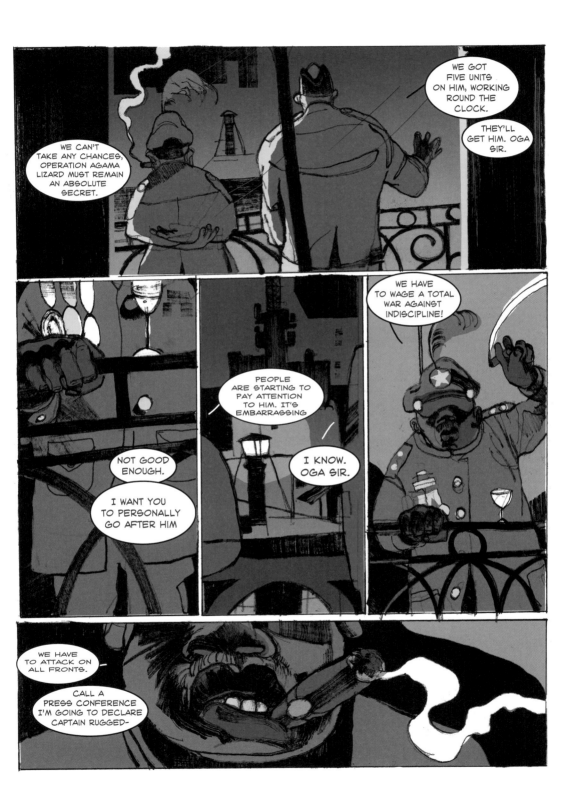

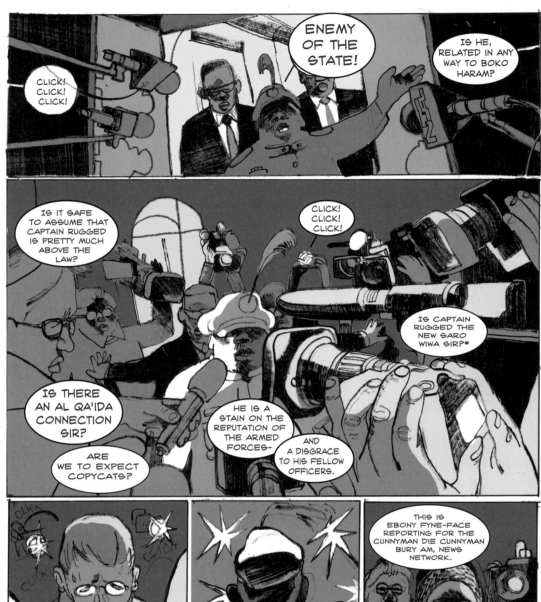

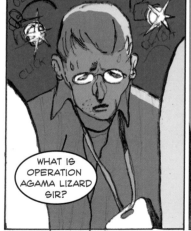

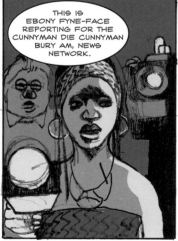

WITHIN HOURS OF THE ARMY
ANNOUNCEMENT, JOURNALISTS
FROM ALL OVER THE WORLD
DESCENDED ON LAGOS.

IT WAS A HIGH SPEED MEDIA
CHASE. EVERY MAJOR NETWORK
HAD A REPORTER ON THE GROUND
RUNNING AFTER CAPTAIN RUGGED

BUT SOME REPORTERS
WERE CLOSER THAN OTHERS.

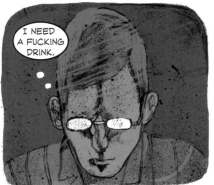

I NEED
A FUCKING
DRINK.

MR PASCALE LE NEGRE
WROTE ARTICLES THAT NO
ONE EVER READS FOR A
FRENCH DAILY NEWSPAPER
CALLED "LE CANARD
LAQUEE"

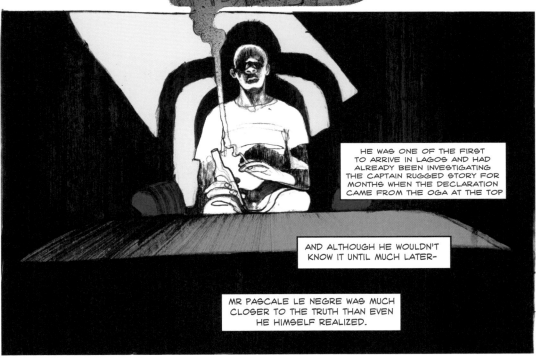

HE WAS ONE OF THE FIRST
TO ARRIVE IN LAGOS AND HAD
ALREADY BEEN INVESTIGATING
THE CAPTAIN RUGGED STORY FOR
MONTHS WHEN THE DECLARATION
CAME FROM THE OGA AT THE TOP

AND ALTHOUGH HE WOULDN'T
KNOW IT UNTIL MUCH LATER—

MR PASCALE LE NEGRE WAS MUCH
CLOSER TO THE TRUTH THAN EVEN
HE HIMSELF REALIZED.

HE'D STOPPED BY MADAM WAZOBIA'S
FOR A DRINK AFTER YET ANOTHER
FRUITLESS DAY AT WORK.

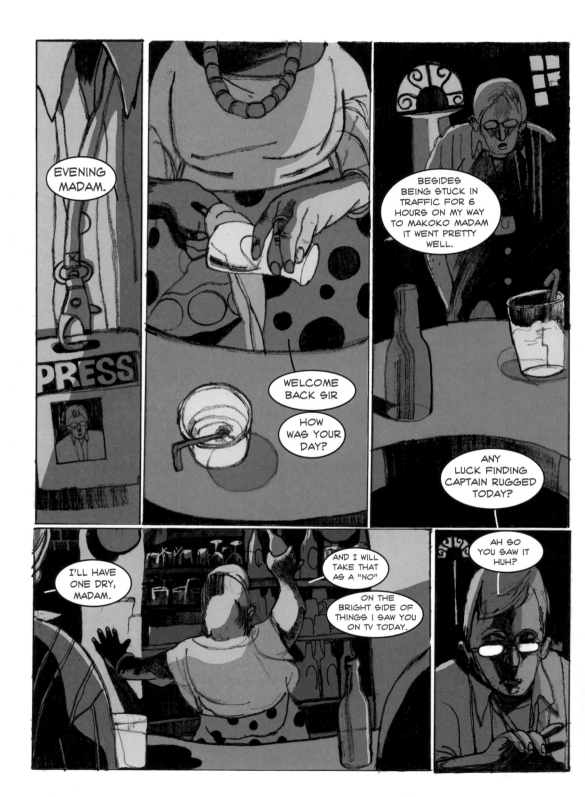

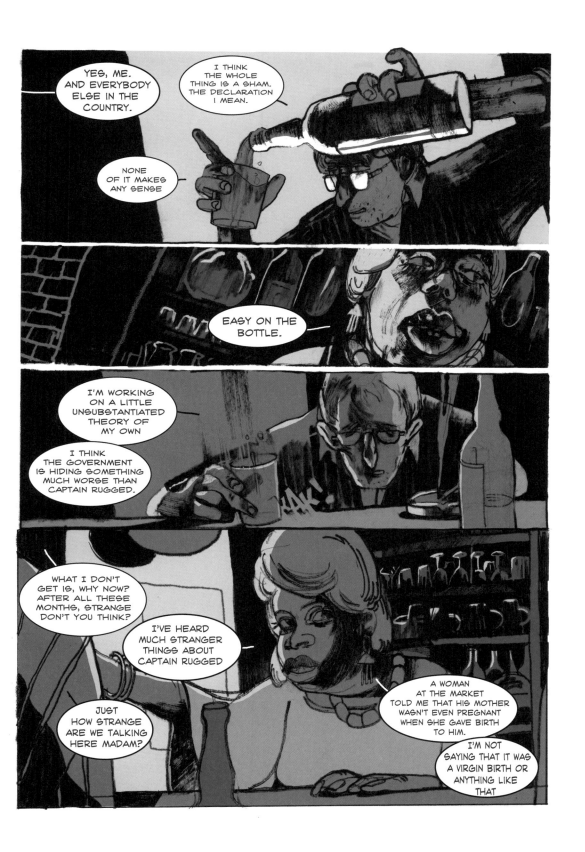

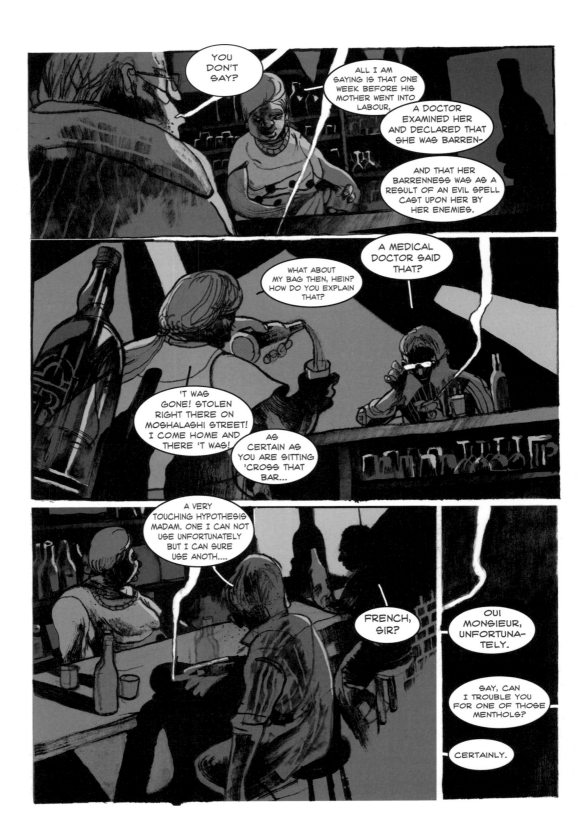

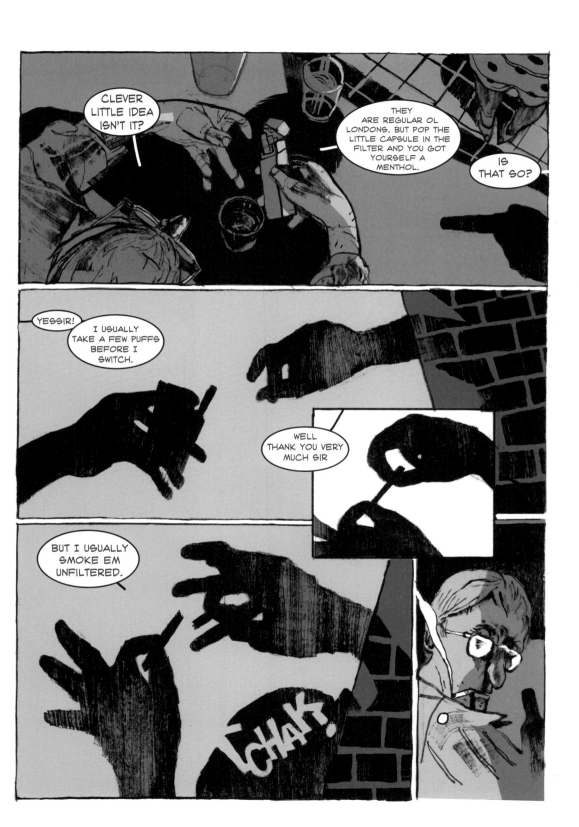

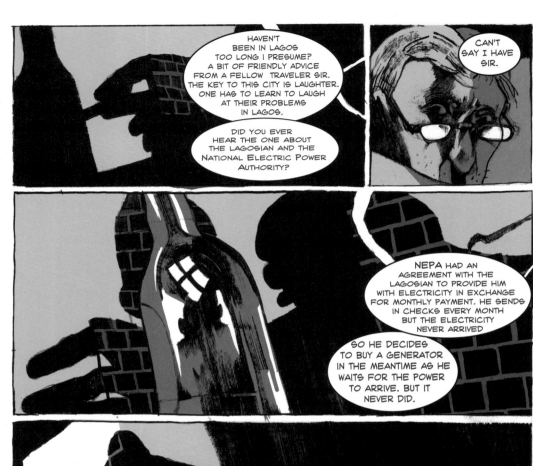

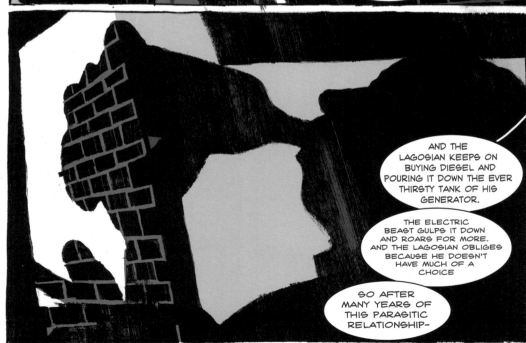

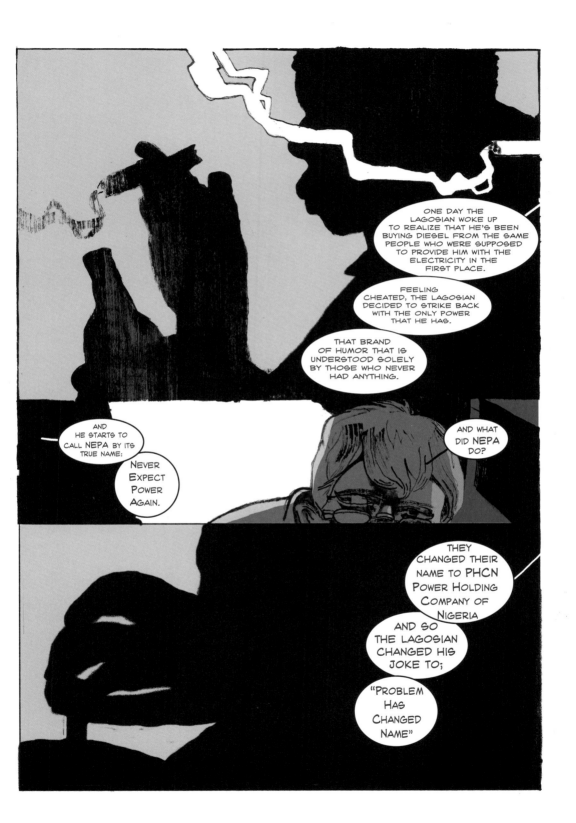

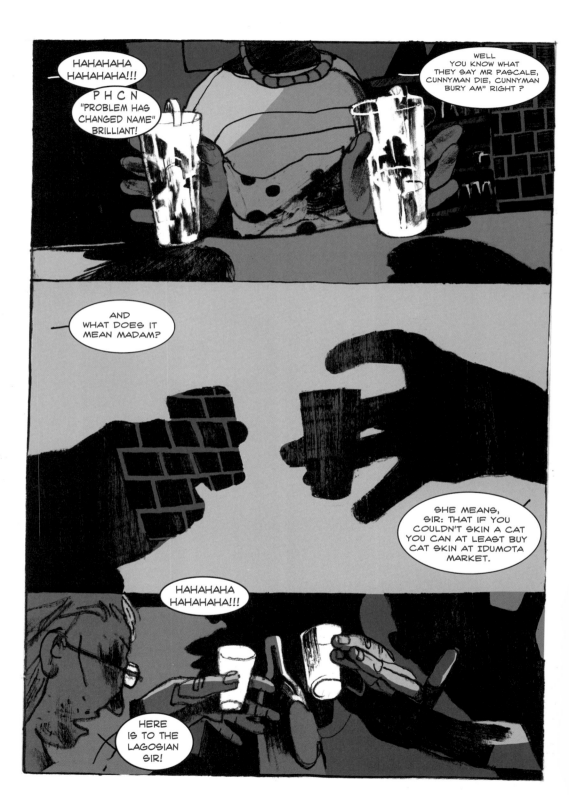

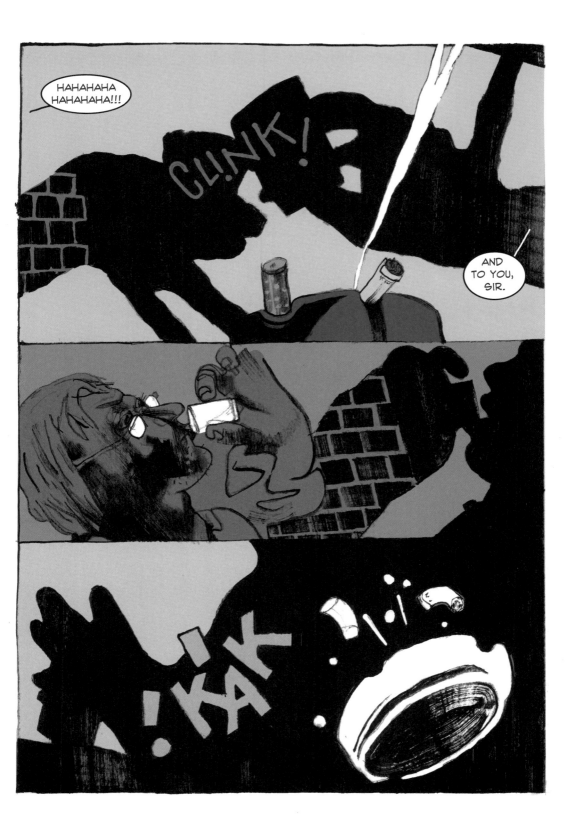

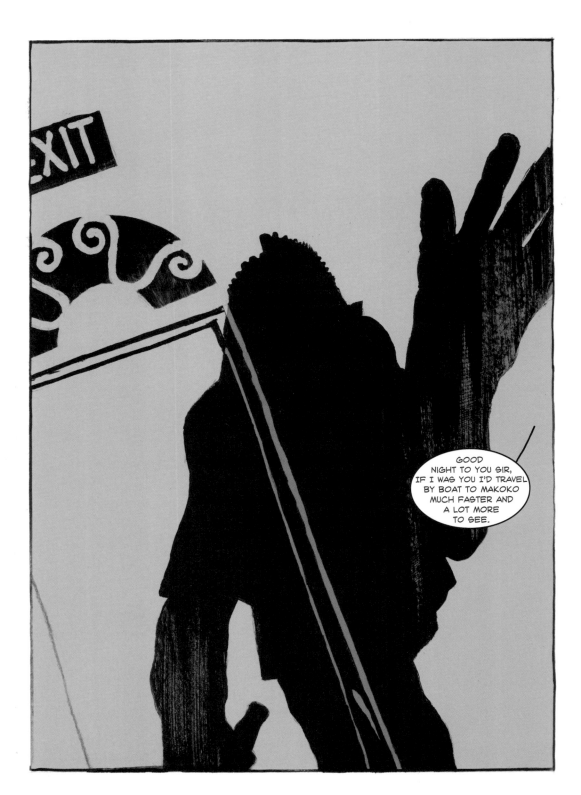

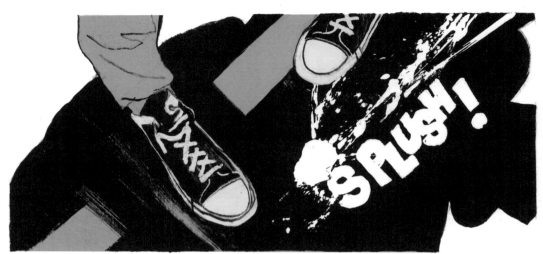

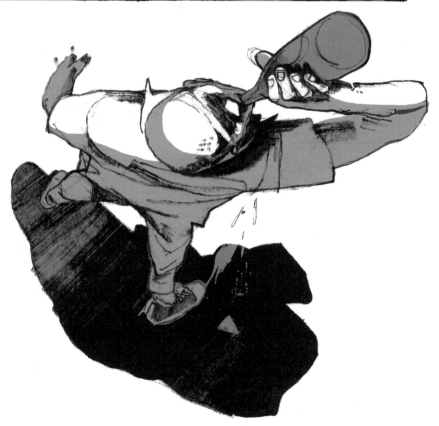

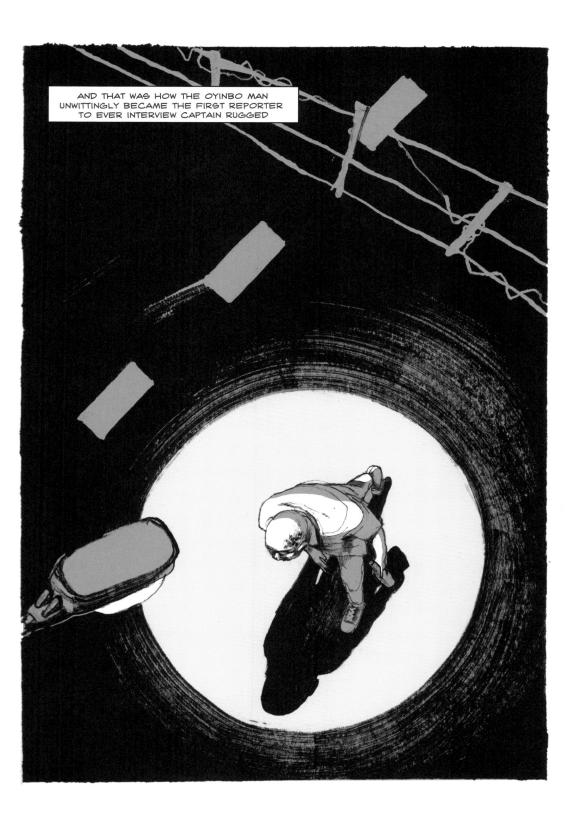

CAPTAIN RUGGED'S SECOND SUPERHERO ACT OCCURRED SHORTLY THEREAFTER.

THIS HOUSE IS NOT FOR SALE

SOMETHING INVOLVING A STRAY DOG, LUCKY AND GODBLESS A 38 SPECIAL AND EVIL SPIRITS.

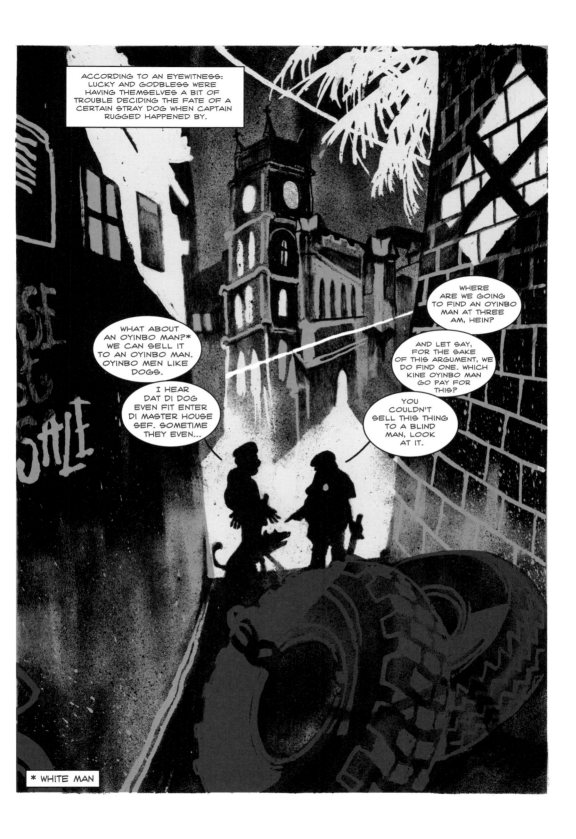

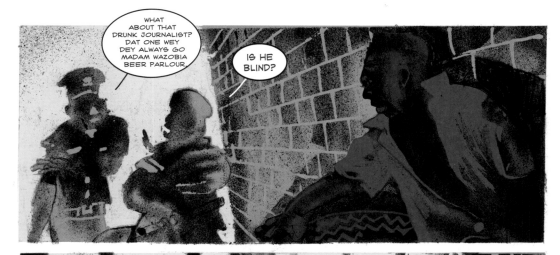

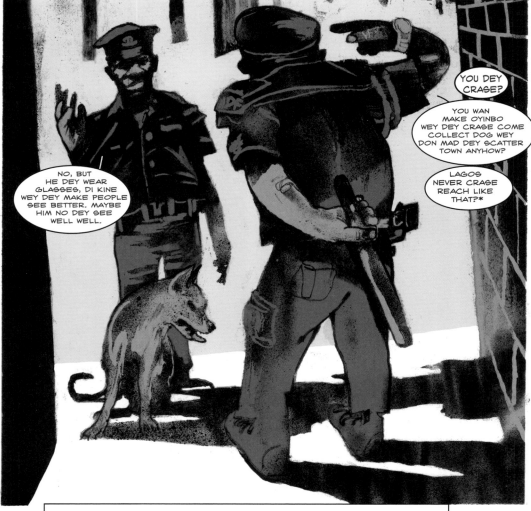

*ARE YOU INSANE? YOU WANT TO SELL AN EVIL DOG TO CRAZY WHITE MAN AND HAVE THE TWO OF THEM RUNNING LOOSE AROUND THE CITY? ISN'T LAGOS CRAZY ENOUGH AS IT IS?

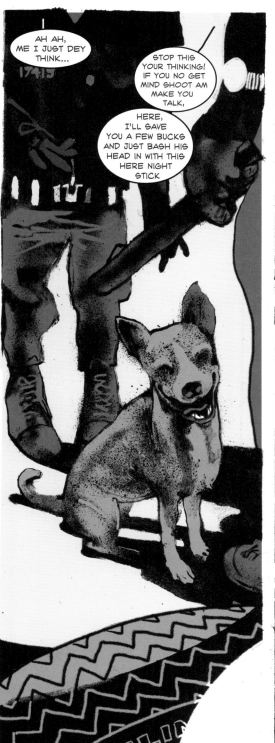
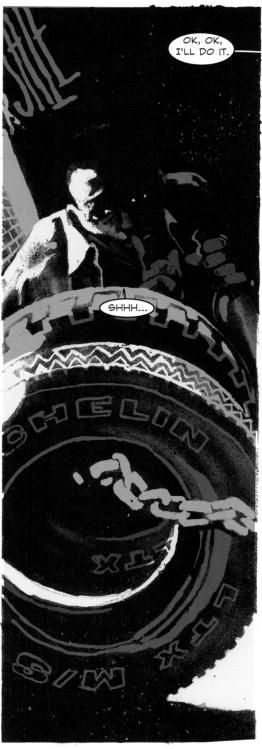

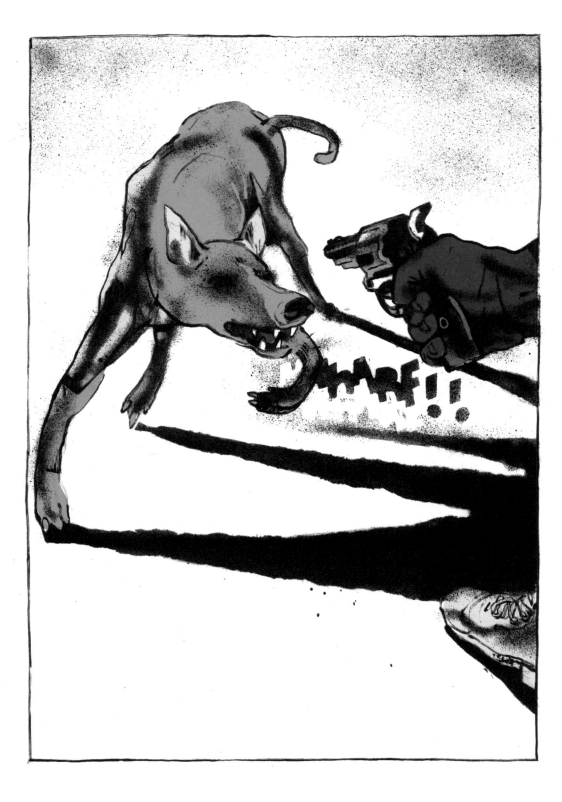

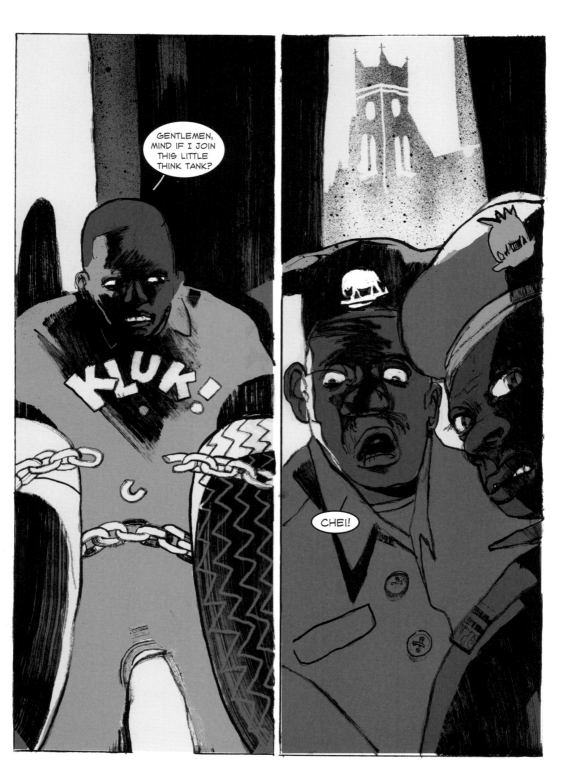

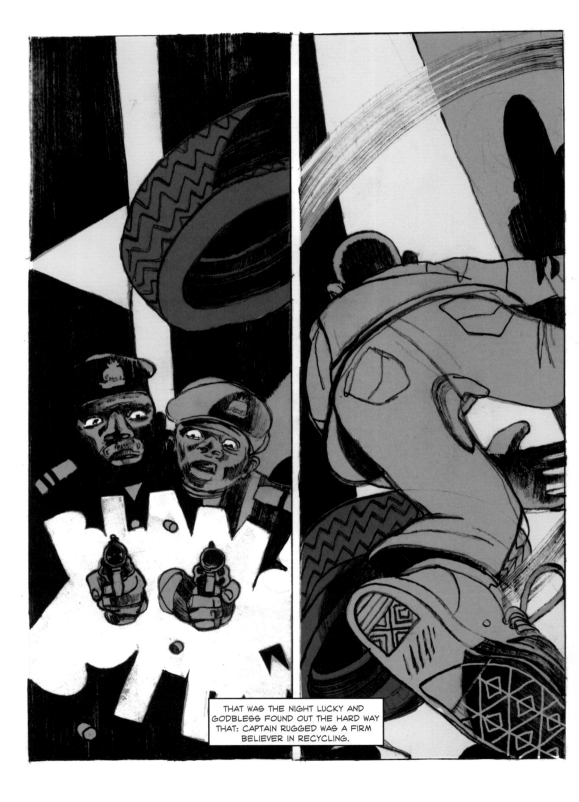

THAT WAS THE NIGHT LUCKY AND GODBLESS FOUND OUT THE HARD WAY THAT: CAPTAIN RUGGED WAS A FIRM BELIEVER IN RECYCLING.

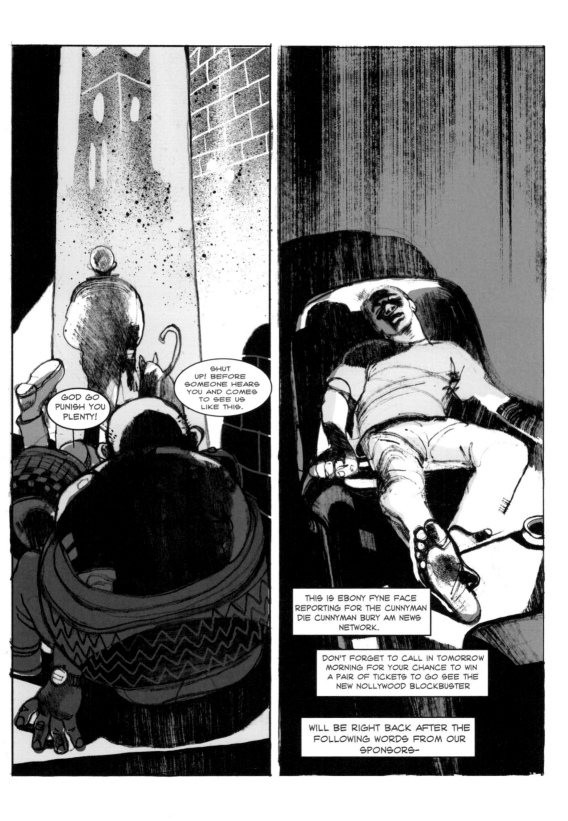

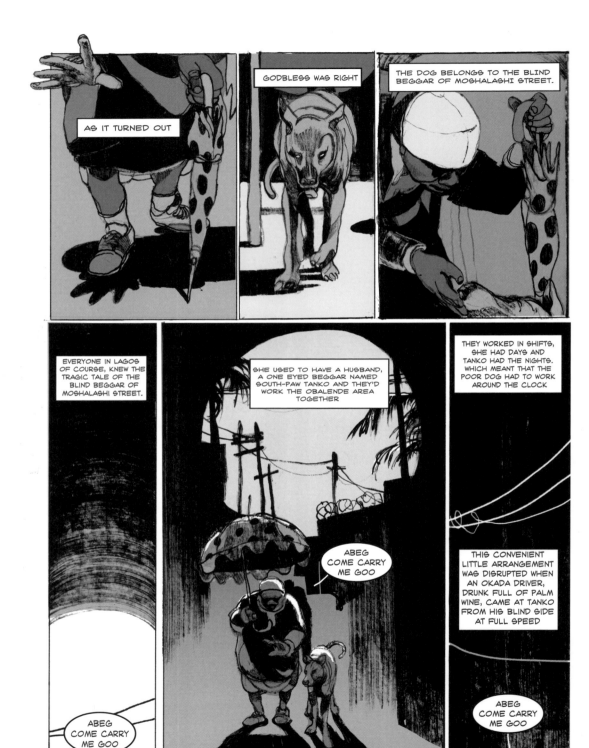

AS IT TURNED OUT

GODBLESS WAS RIGHT

THE DOG BELONGS TO THE BLIND BEGGAR OF MOSHALASHI STREET.

EVERYONE IN LAGOS OF COURSE, KNEW THE TRAGIC TALE OF THE BLIND BEGGAR OF MOSHALASHI STREET.

SHE USED TO HAVE A HUSBAND, A ONE EYED BEGGAR NAMED SOUTH-PAW TANKO AND THEY'D WORK THE OBALENDE AREA TOGETHER

THEY WORKED IN SHIFTS, SHE HAD DAYS AND TANKO HAD THE NIGHTS. WHICH MEANT THAT THE POOR DOG HAD TO WORK AROUND THE CLOCK

ABEG COME CARRY ME GOO

THIS CONVENIENT LITTLE ARRANGEMENT WAS DISRUPTED WHEN AN OKADA DRIVER, DRUNK FULL OF PALM WINE, CAME AT TANKO FROM HIS BLIND SIDE AT FULL SPEED

ABEG COME CARRY ME GOO

ABEG COME CARRY ME GOO

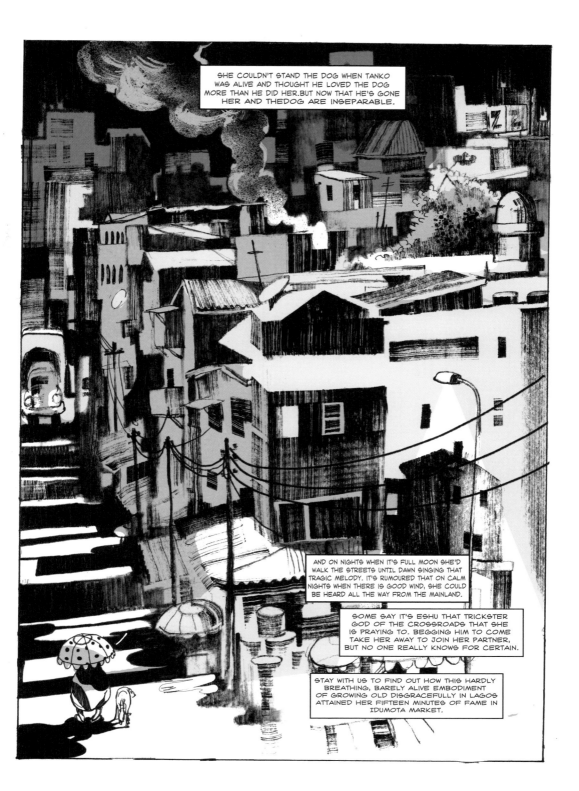

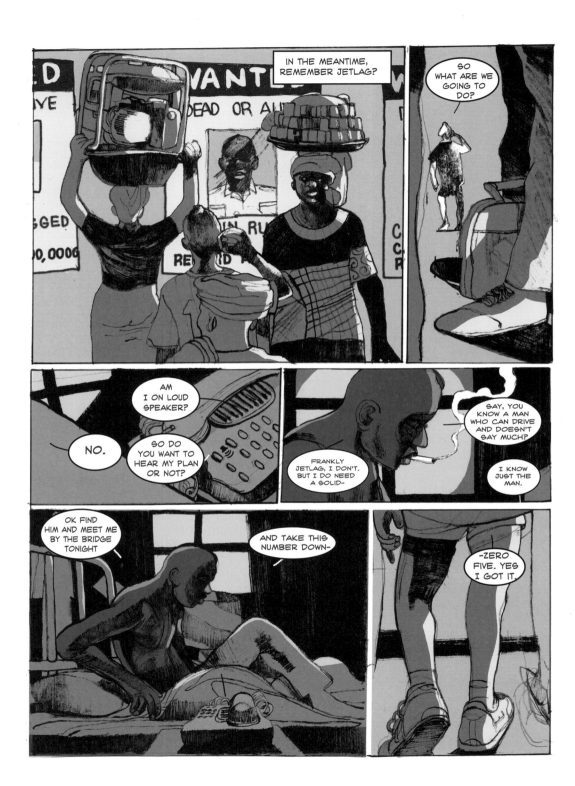

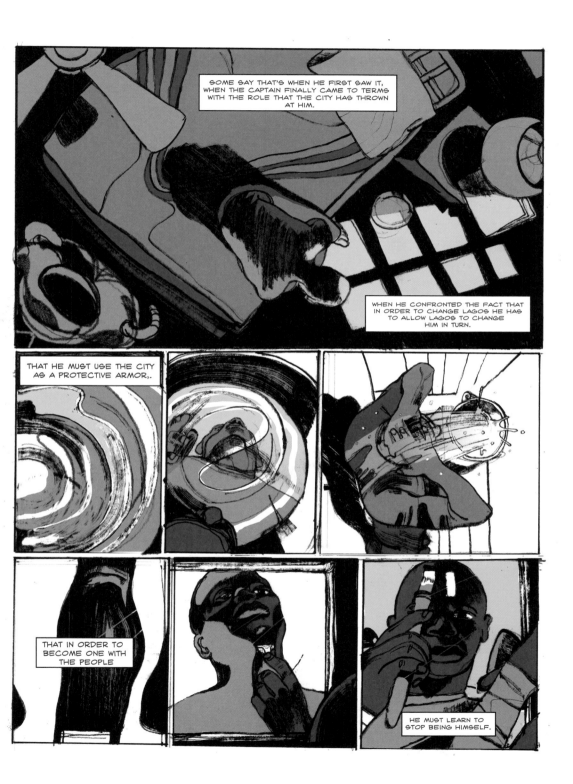

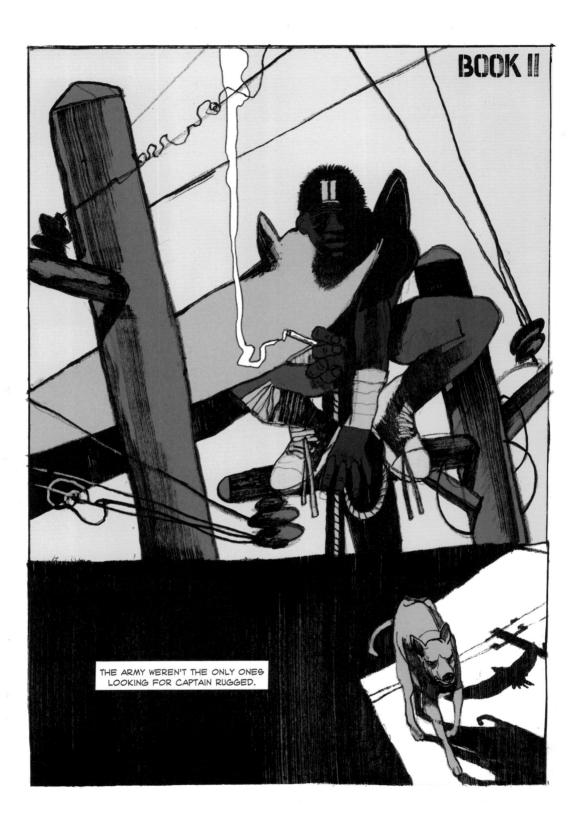

BOOK II

THE ARMY WEREN'T THE ONLY ONES
LOOKING FOR CAPTAIN RUGGED.

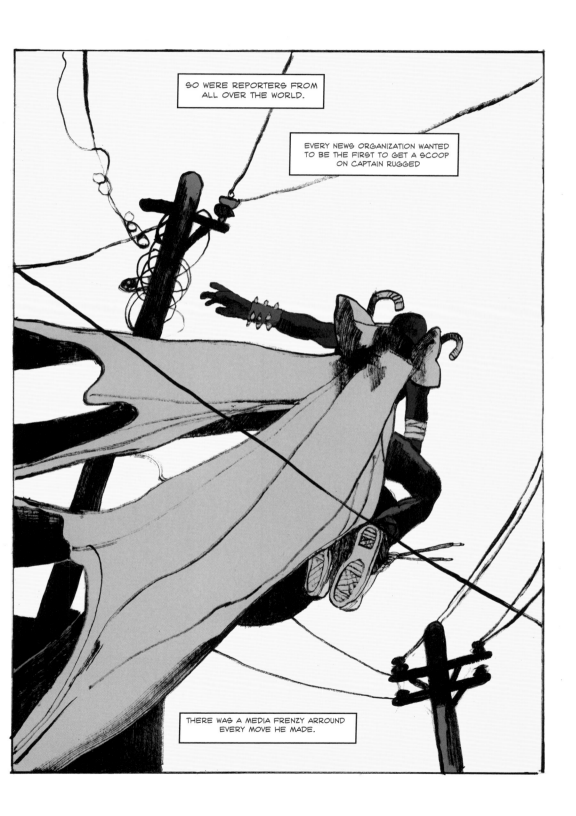

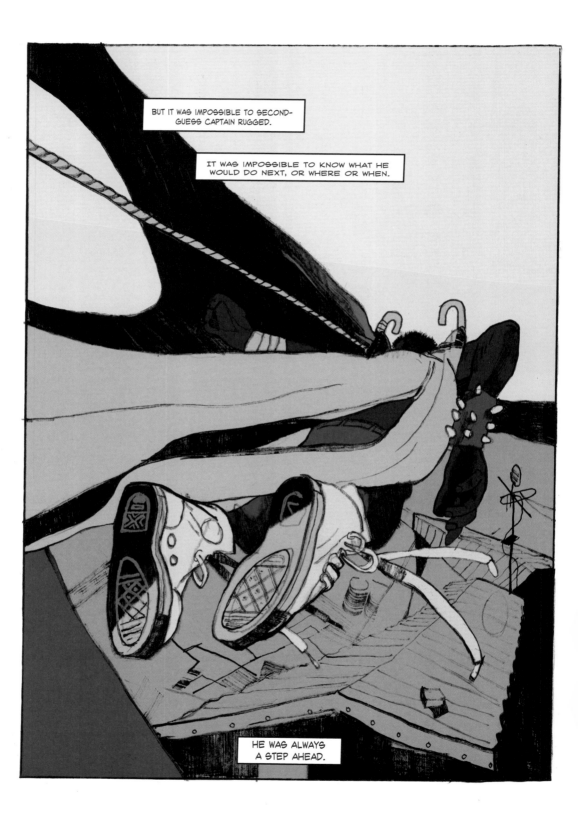

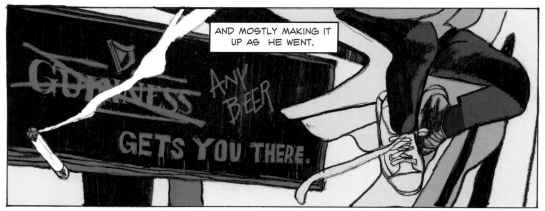

AND MOSTLY MAKING IT UP AS HE WENT.

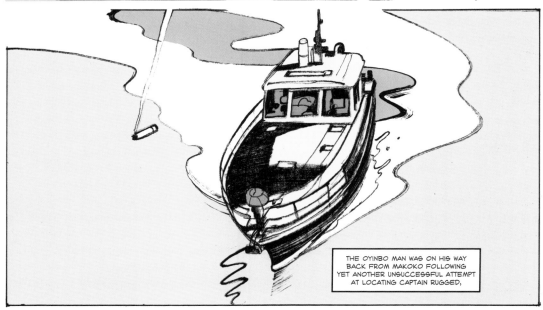

THE OYINBO MAN WAS ON HIS WAY BACK FROM MAKOKO FOLLOWING YET ANOTHER UNSUCCESSFUL ATTEMPT AT LOCATING CAPTAIN RUGGED,

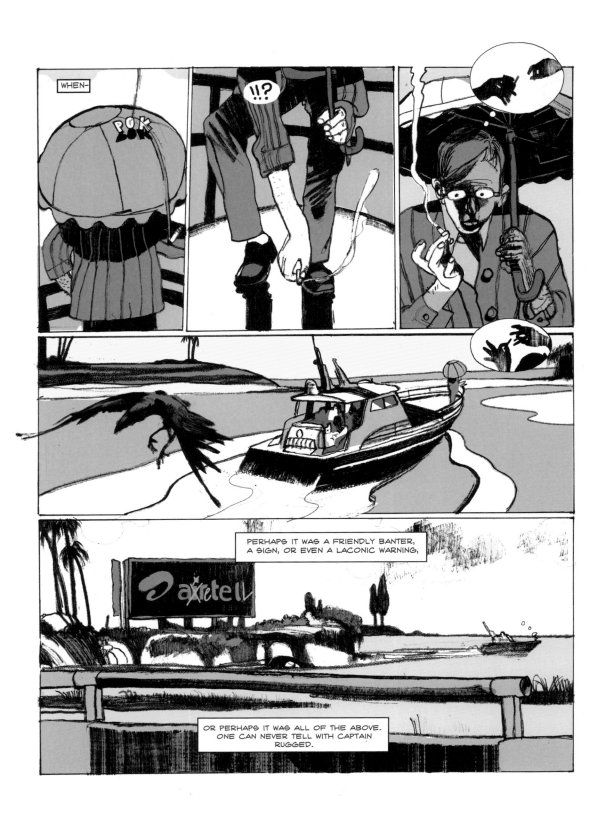

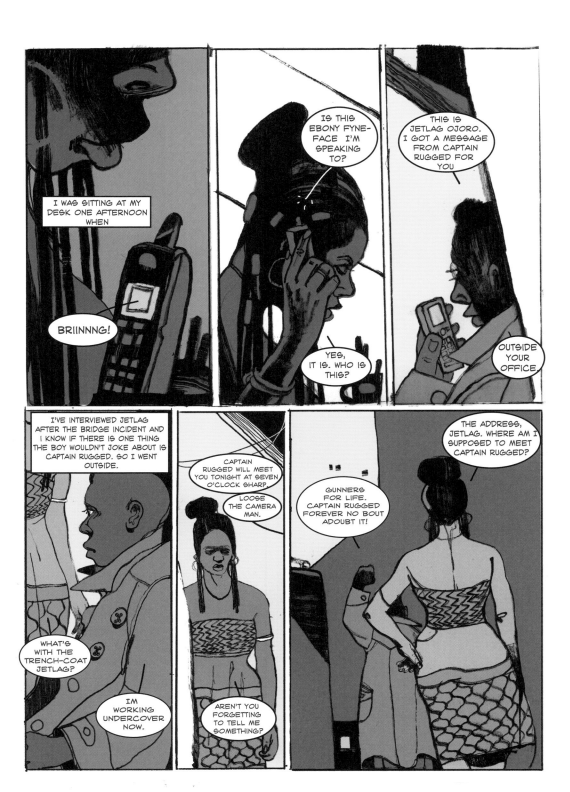

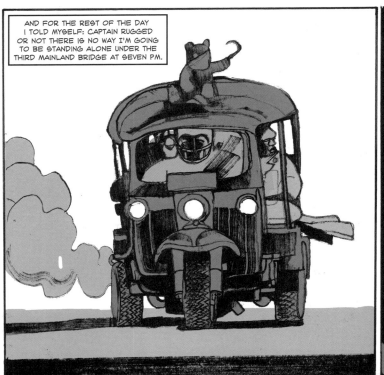

AND FOR THE REST OF THE DAY I TOLD MYSELF: CAPTAIN RUGGED OR NOT THERE IS NO WAY I'M GOING TO BE STANDING ALONE UNDER THE THIRD MAINLAND BRIDGE AT SEVEN P.M.

BUT THERE I WAS.

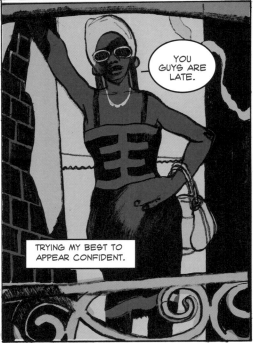

YOU GUYS ARE LATE.

TRYING MY BEST TO APPEAR CONFIDENT.

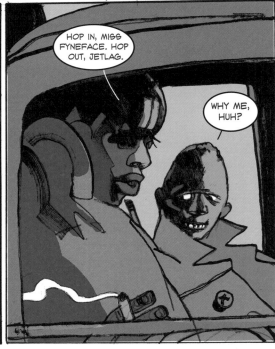

HOP IN, MISS FYNEFACE. HOP OUT, JETLAG.

WHY ME, HUH?

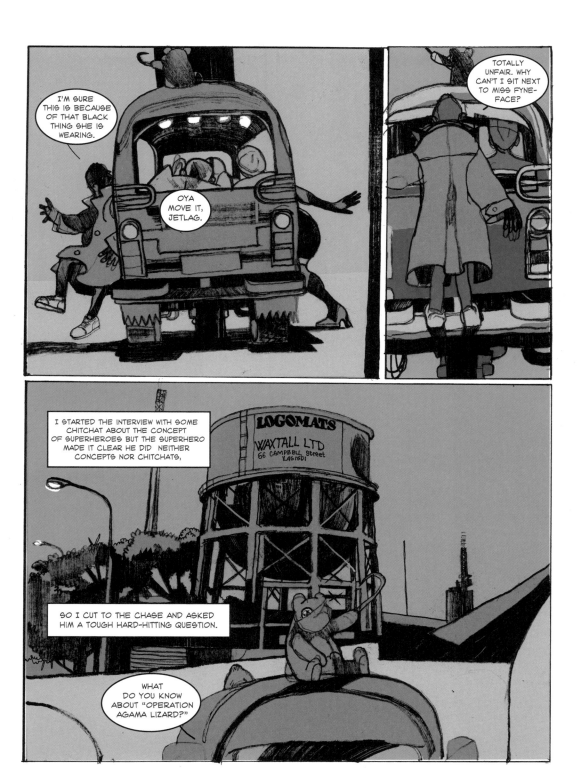

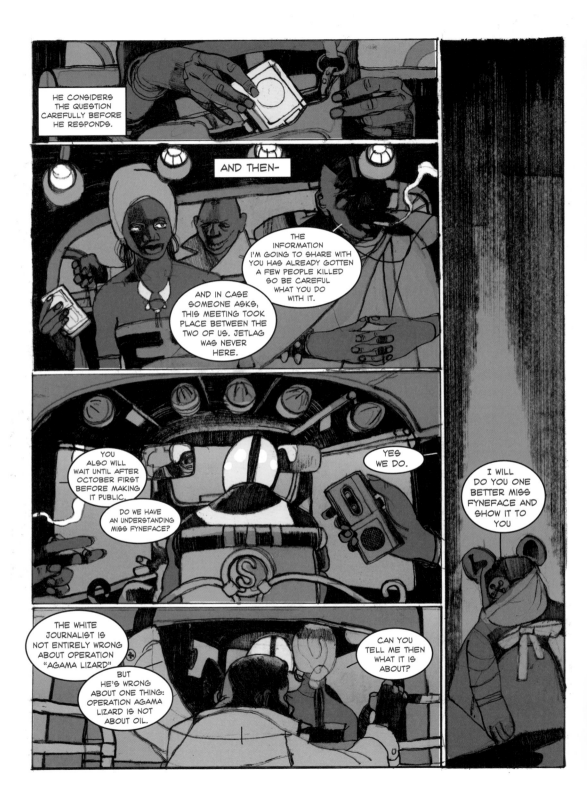

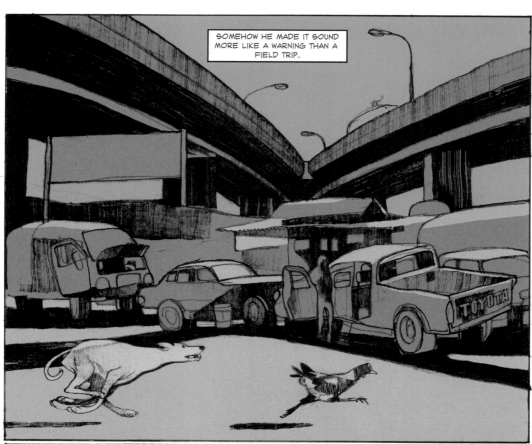

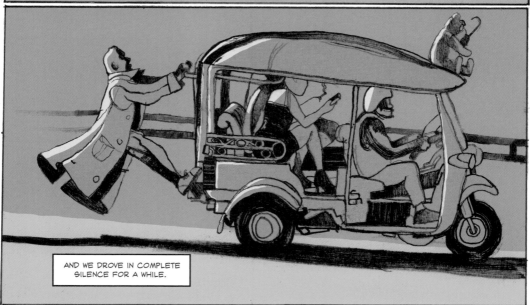

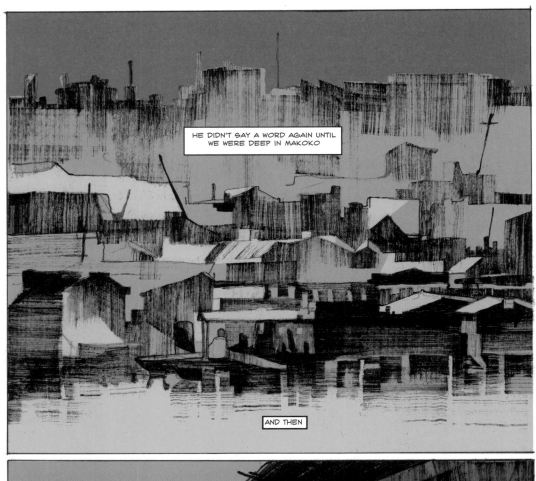

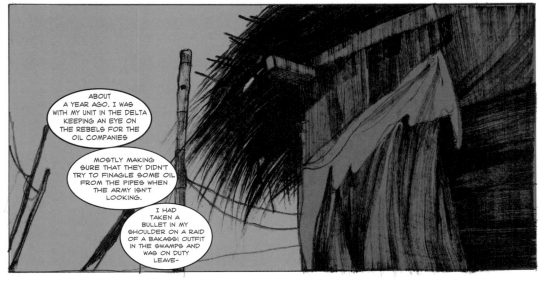

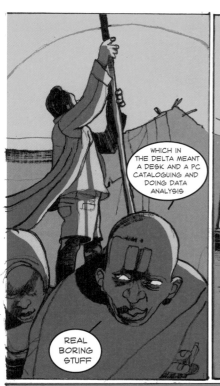

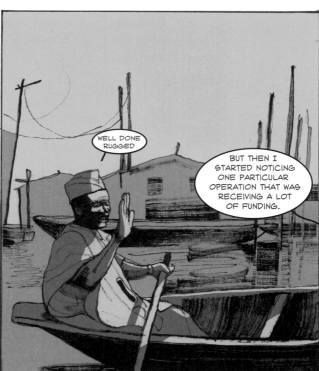

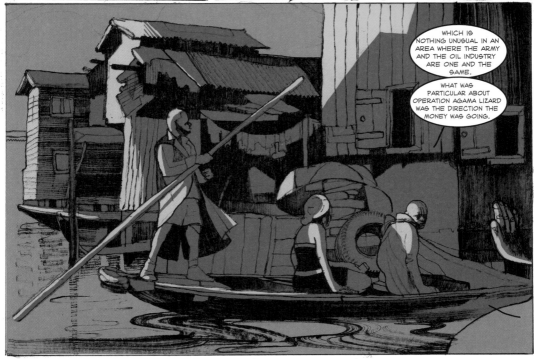

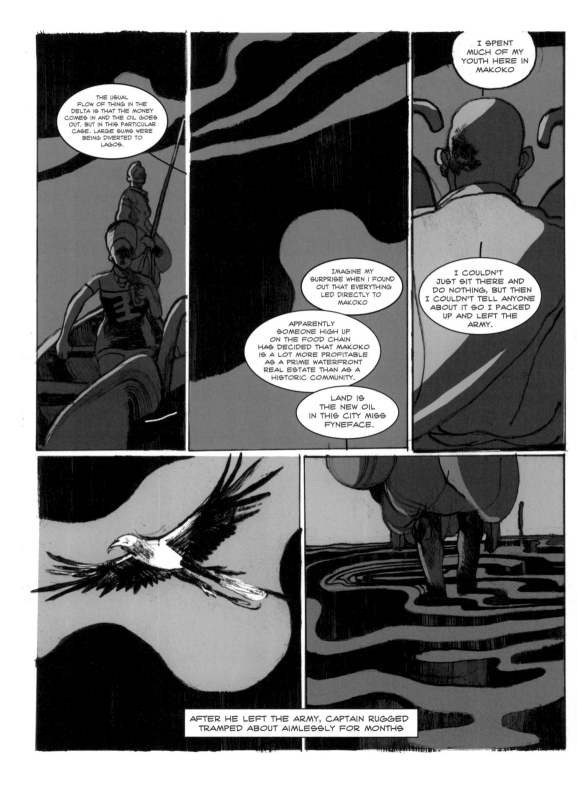

AFTER HE LEFT THE ARMY, CAPTAIN RUGGED TRAMPED ABOUT AIMLESSLY FOR MONTHS

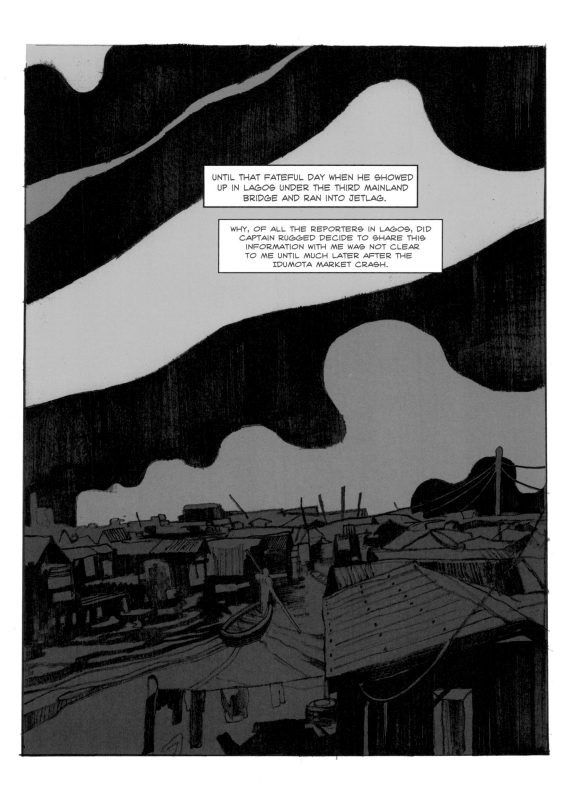

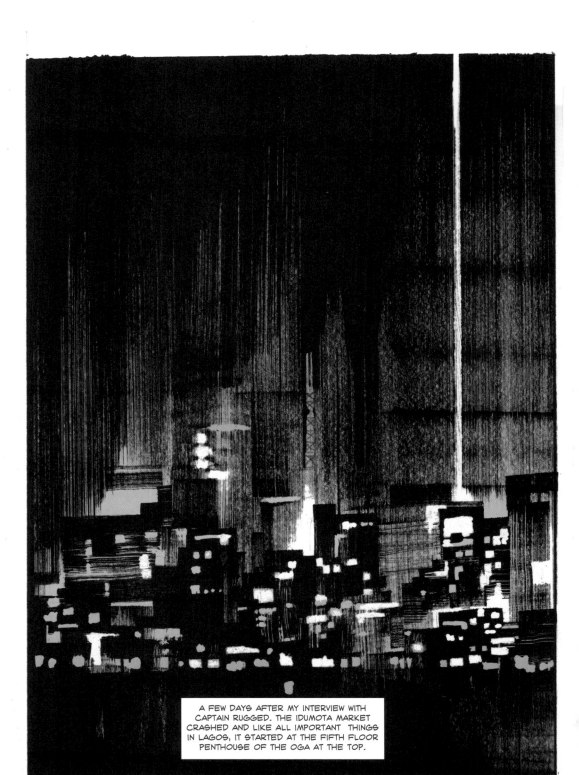

A FEW DAYS AFTER MY INTERVIEW WITH CAPTAIN RUGGED. THE IDUMOTA MARKET CRASHED AND LIKE ALL IMPORTANT THINGS IN LAGOS, IT STARTED AT THE FIFTH FLOOR PENTHOUSE OF THE OGA AT THE TOP.

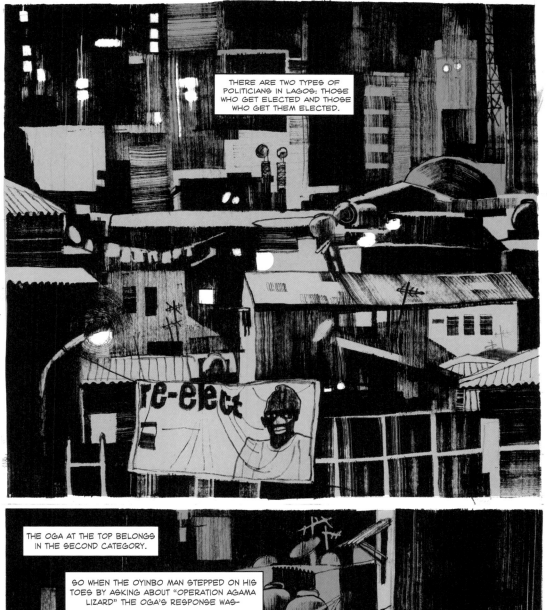

THERE ARE TWO TYPES OF POLITICIANS IN LAGOS: THOSE WHO GET ELECTED AND THOSE WHO GET THEM ELECTED.

re-elect

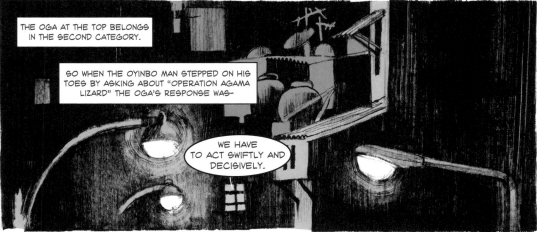

THE OGA AT THE TOP BELONGS IN THE SECOND CATEGORY.

SO WHEN THE OYINBO MAN STEPPED ON HIS TOES BY ASKING ABOUT "OPERATION AGAMA LIZARD" THE OGA'S RESPONSE WAS—

WE HAVE TO ACT SWIFTLY AND DECISIVELY.

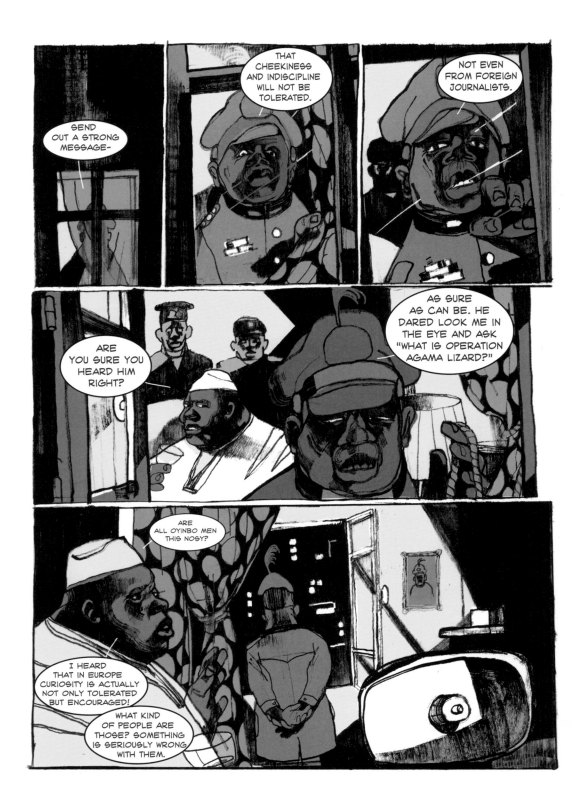

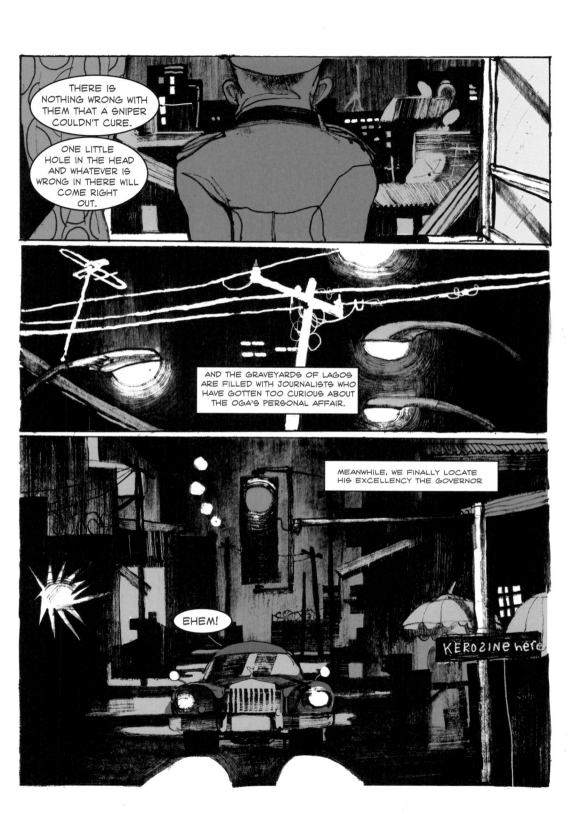

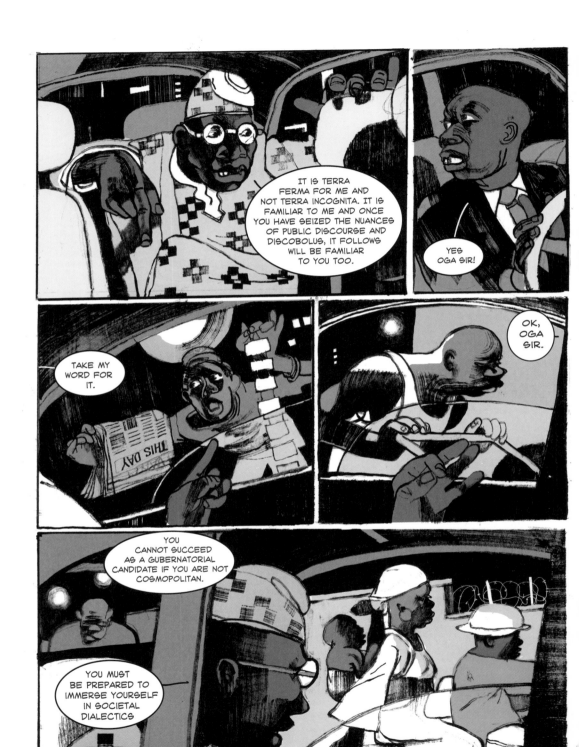

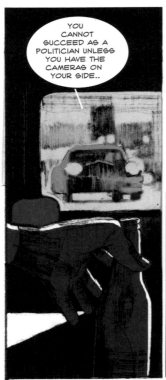

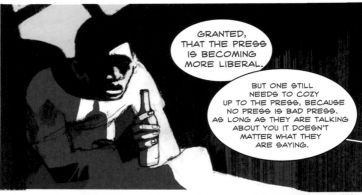

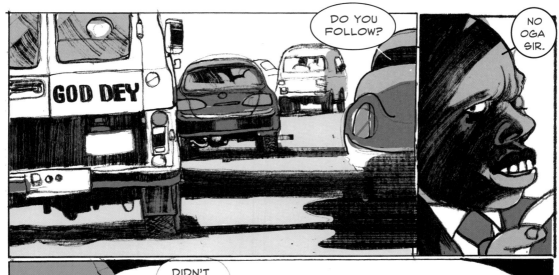

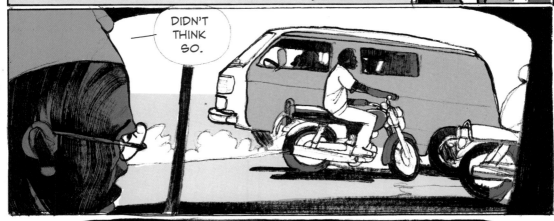

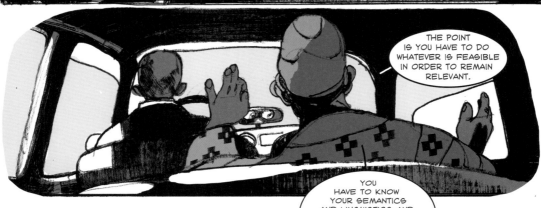

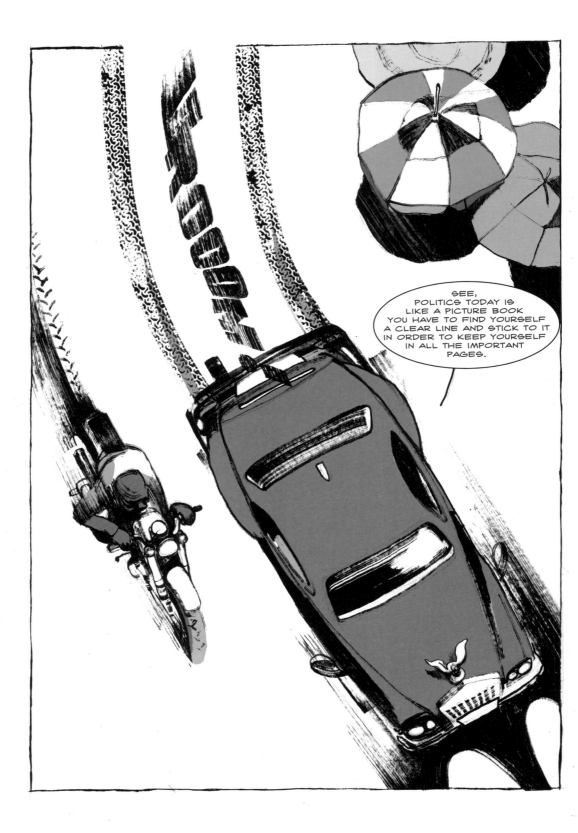

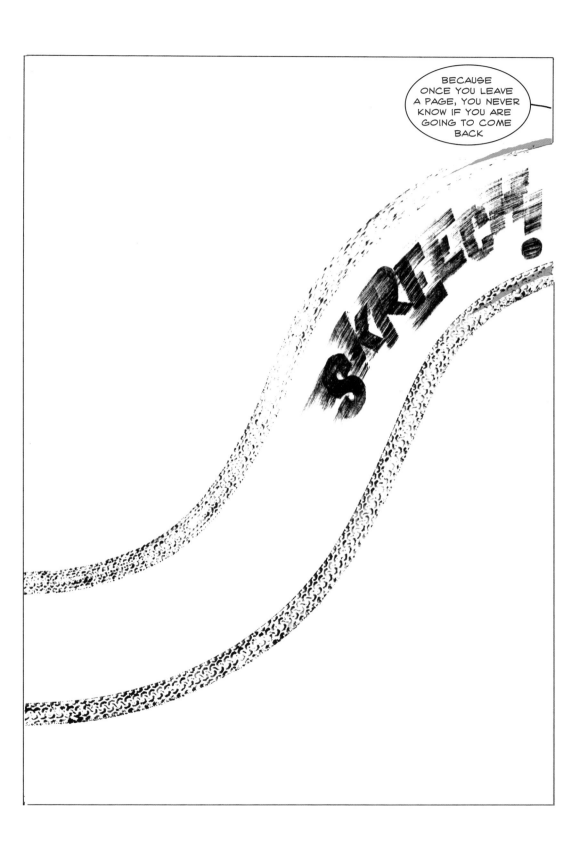

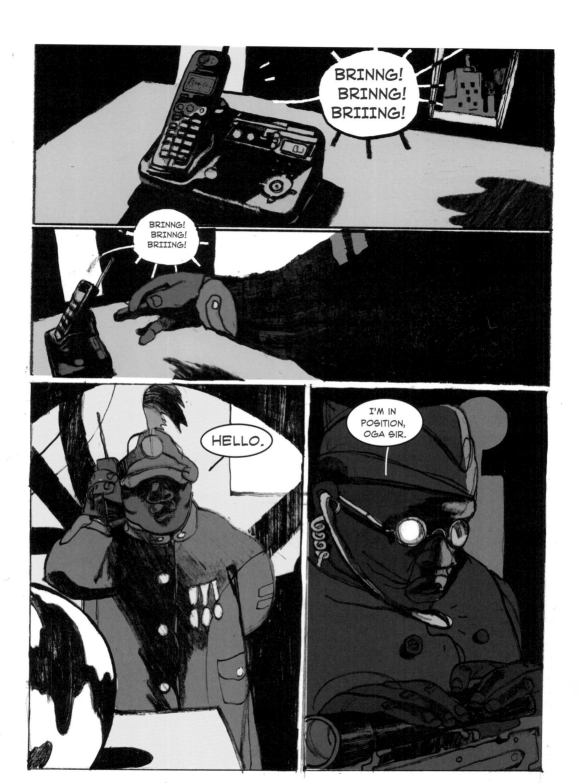

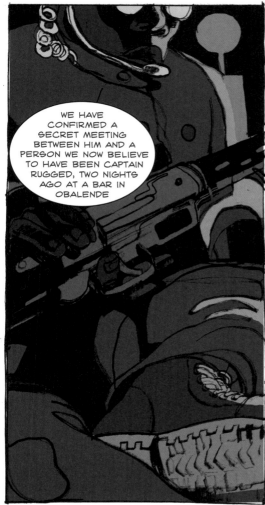

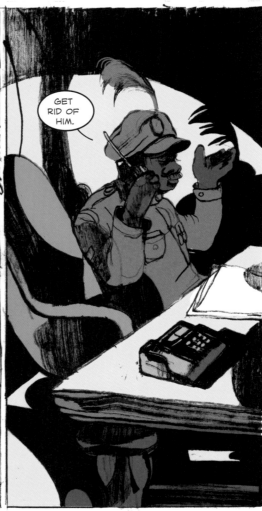

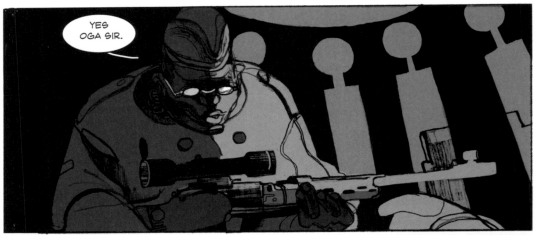

YES OGA SIR.

AND THE GIRL? OGA SIR.

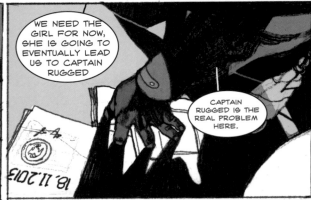

WE NEED THE GIRL FOR NOW, SHE IS GOING TO EVENTUALLY LEAD US TO CAPTAIN RUGGED

CAPTAIN RUGGED IS THE REAL PROBLEM HERE.

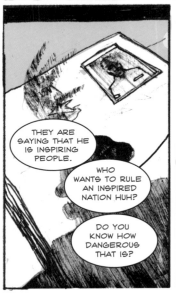

THEY ARE SAYING THAT HE IS INSPIRING PEOPLE.

WHO WANTS TO RULE AN INSPIRED NATION HUH?

DO YOU KNOW HOW DANGEROUS THAT IS?

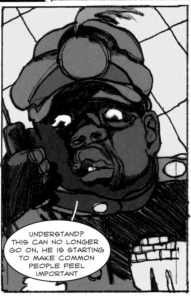

UNDERSTAND? THIS CAN NO LONGER GO ON, HE IS STARTING TO MAKE COMMON PEOPLE FEEL IMPORTANT

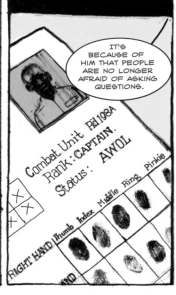

IT'S BECAUSE OF HIM THAT PEOPLE ARE NO LONGER AFRAID OF ASKING QUESTIONS.

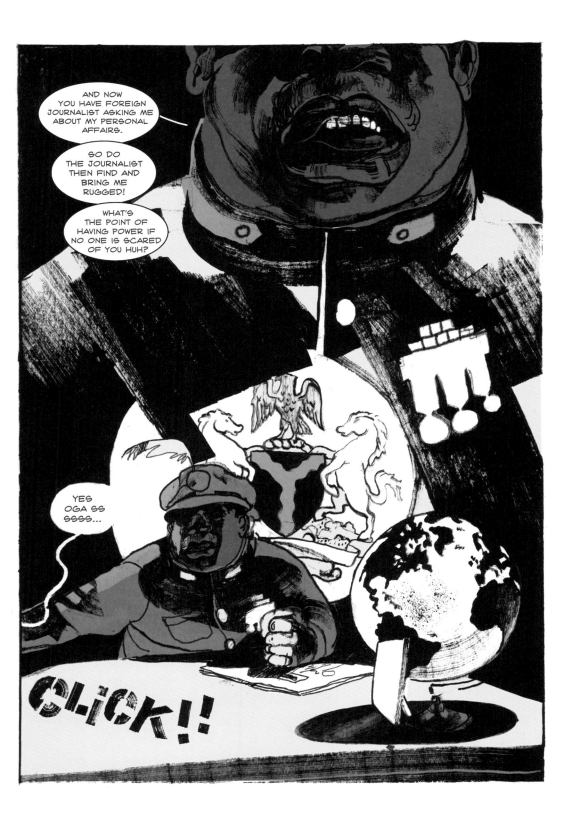

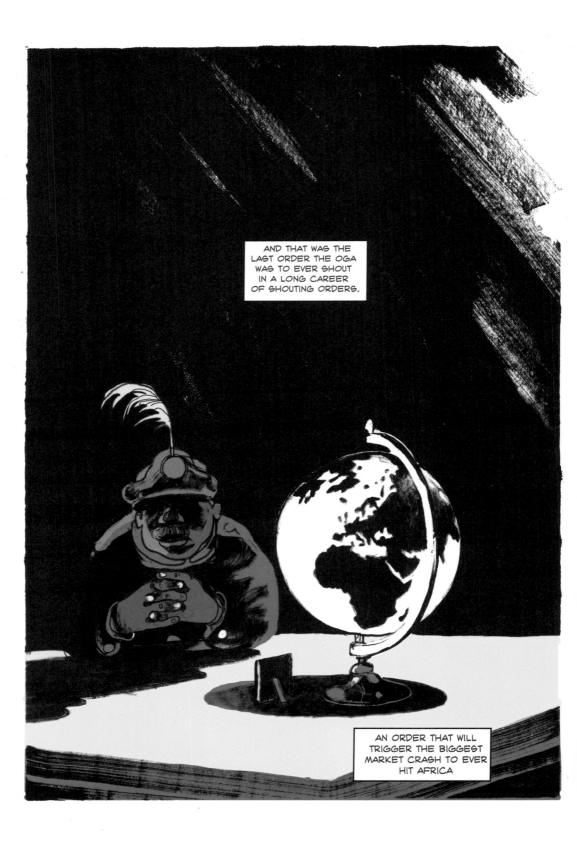

THIS IS EBONY FYNEFACE FOR THE
CUNNYMAN DIE CUNNYMAN BURY AM
NEWS NETWORK WHERE NO NEWS IS
BAD NEWS AND IF IT HAPPENED
THEN WE PROBABLY GOT IT ON FILM.

STAY WITH US TO FIND OUT
EXACTLY WHAT HAPPENED
AT IDUMOTA MARKET ON
THE EVENING OF OCTOBER
FIRST.

UP NEXT IS SUNDAY MAGAJI WITH
THE WEATHER REPORT, DON'T
GO AWAY.

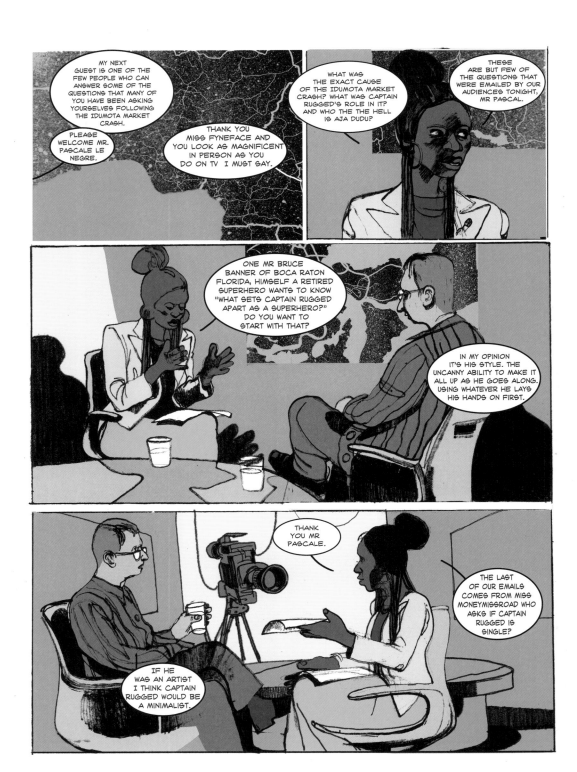

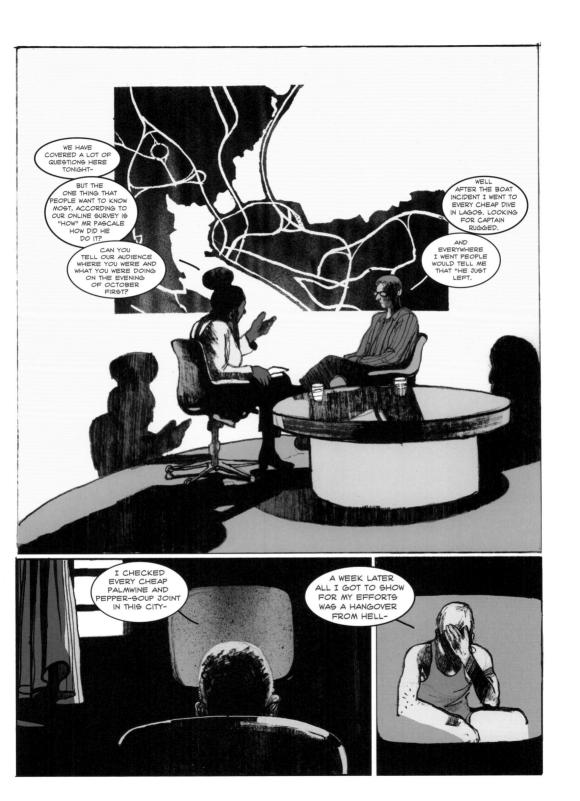

AND A BAD CASE
OF DIARRHEA.

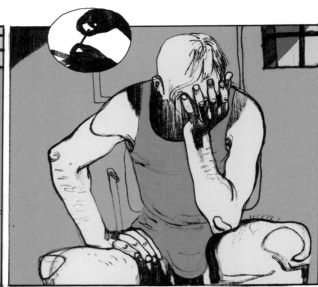

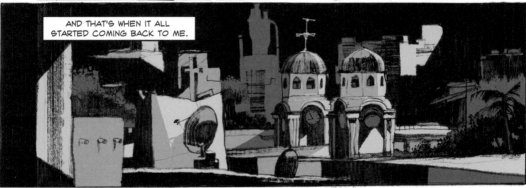
AND THAT'S WHEN IT ALL
STARTED COMING BACK TO ME.

SITTING RIGHT THERE
ON THE SHITTER.

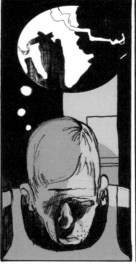

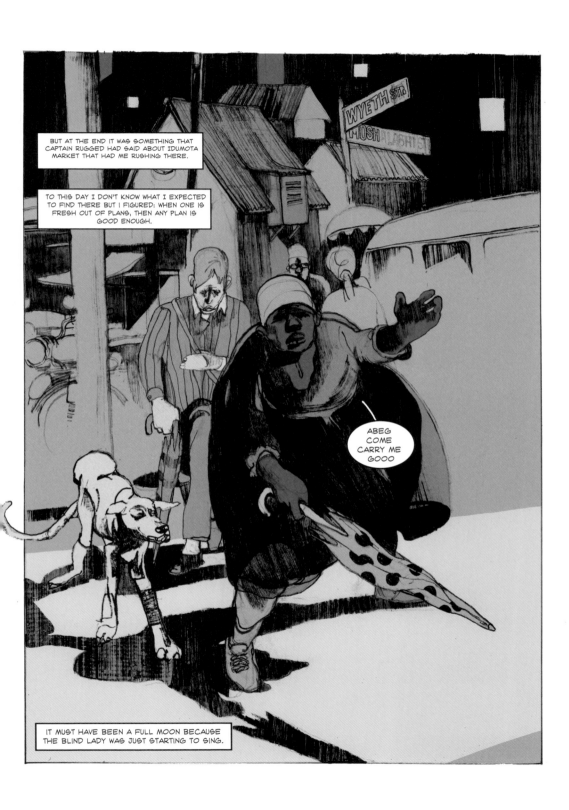

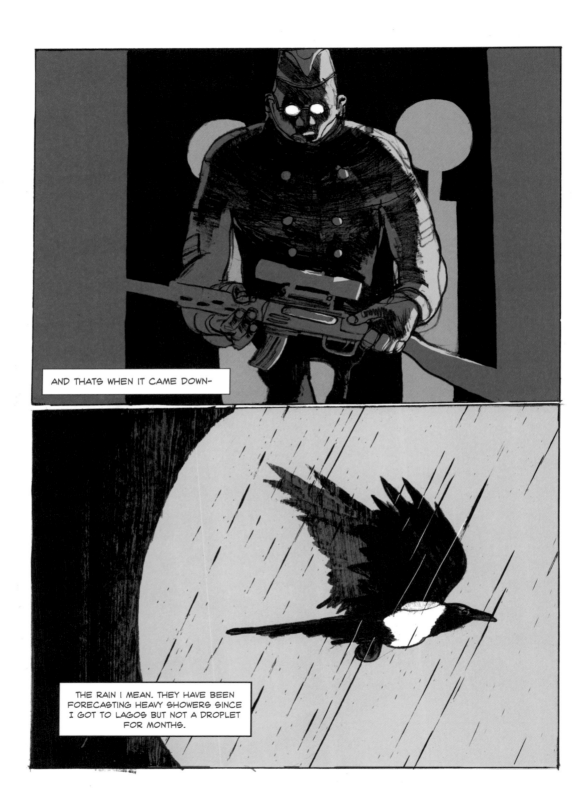

AND THATS WHEN IT CAME DOWN—

THE RAIN I MEAN. THEY HAVE BEEN
FORECASTING HEAVY SHOWERS SINCE
I GOT TO LAGOS BUT NOT A DROPLET
FOR MONTHS.

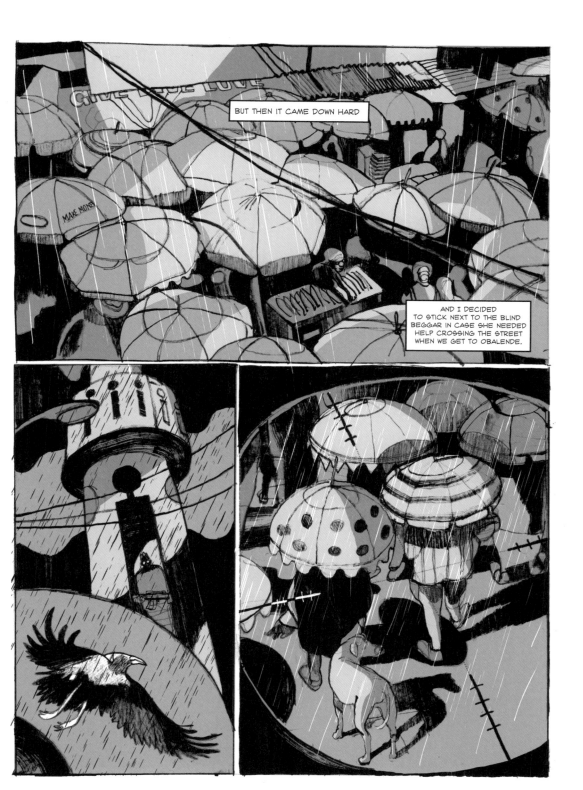

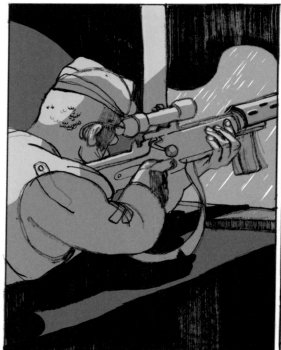

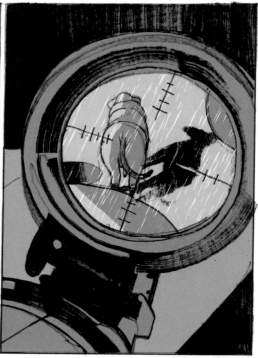

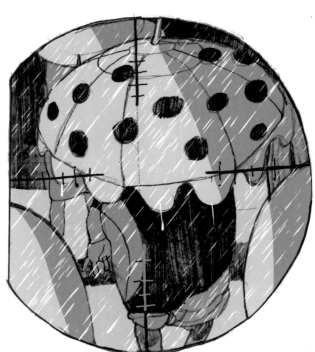

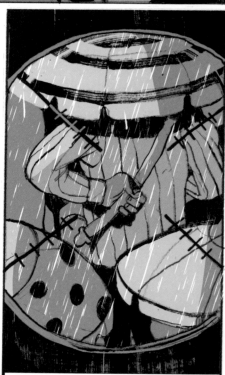

IT WAS RAINING AS IF ALL THE MADNESS THAT WAS THE LAST FEW MONTHS HAD SOMEHOW BEEN GATHERING ABOVE THE CITY-

-INTO A SINISTER BALL OF RAGE AND IS NOW FINALLY POURING BACK DOWN TO WASH THE STREET OF LAGOS CLEAN

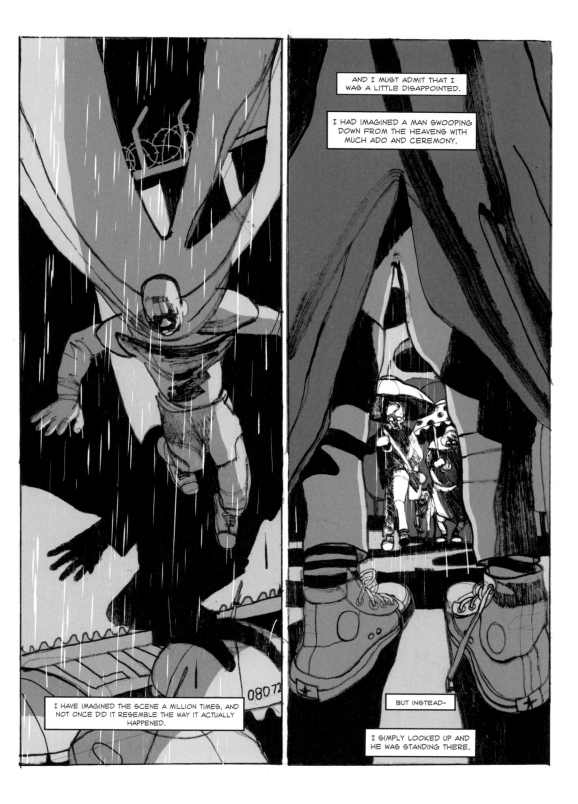

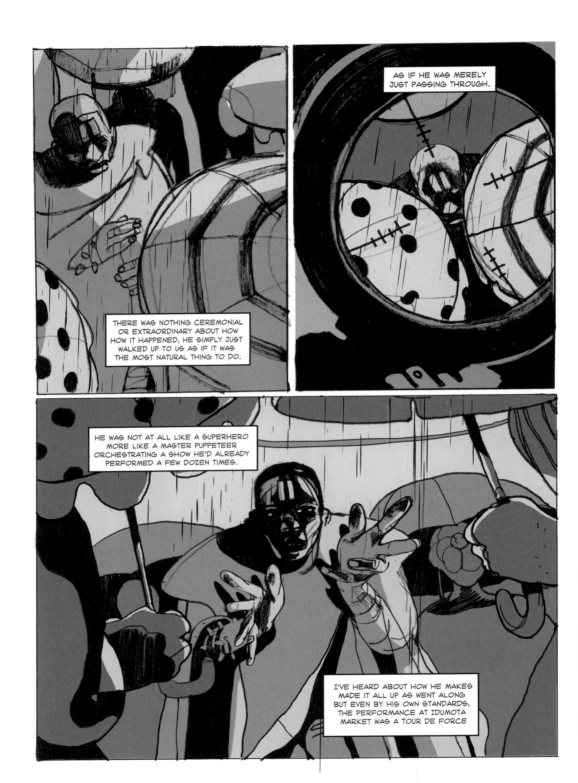

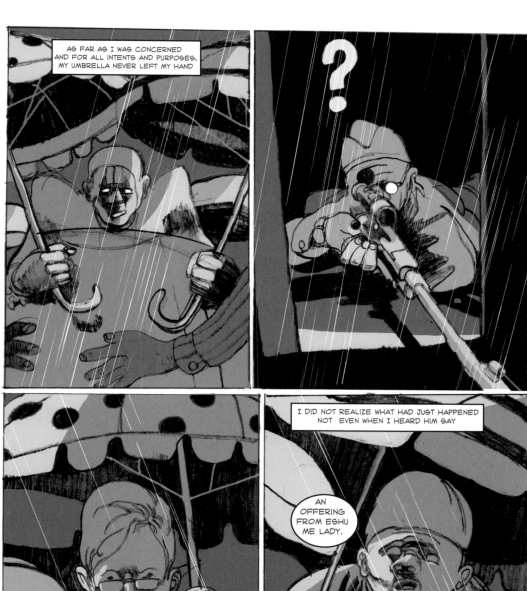

AS FAR AS I WAS CONCERNED AND FOR ALL INTENTS AND PURPOSES, MY UMBRELLA NEVER LEFT MY HAND

?

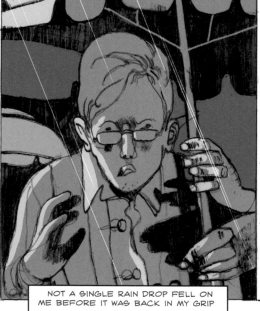

NOT A SINGLE RAIN DROP FELL ON ME BEFORE IT WAS BACK IN MY GRIP

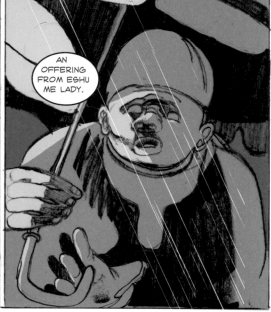

I DID NOT REALIZE WHAT HAD JUST HAPPENED NOT EVEN WHEN I HEARD HIM SAY

AN OFFERING FROM ESHU ME LADY.

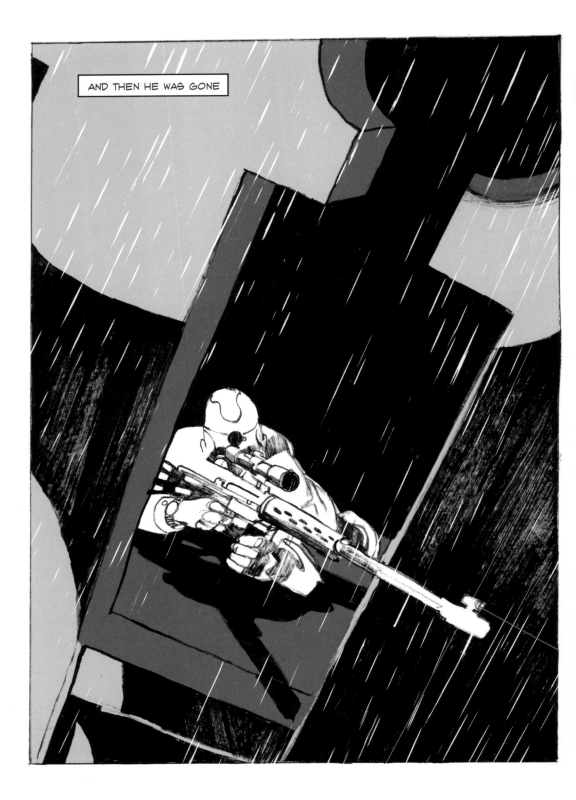

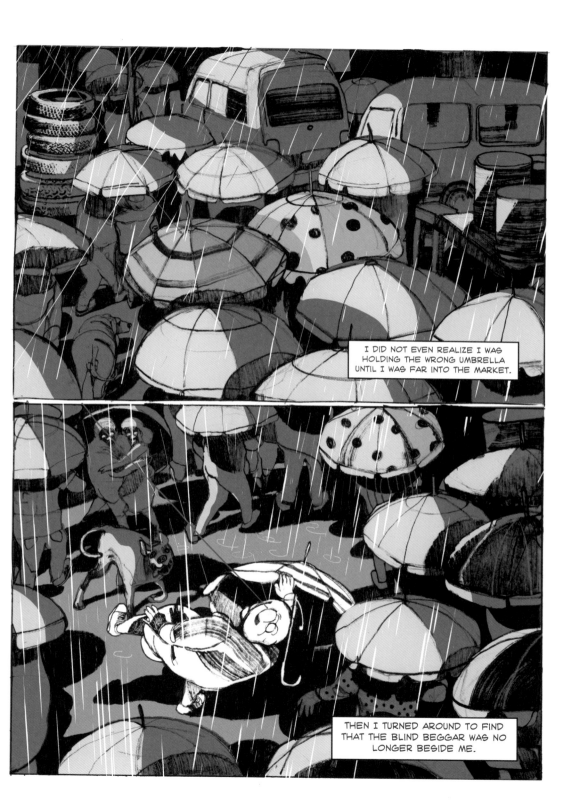

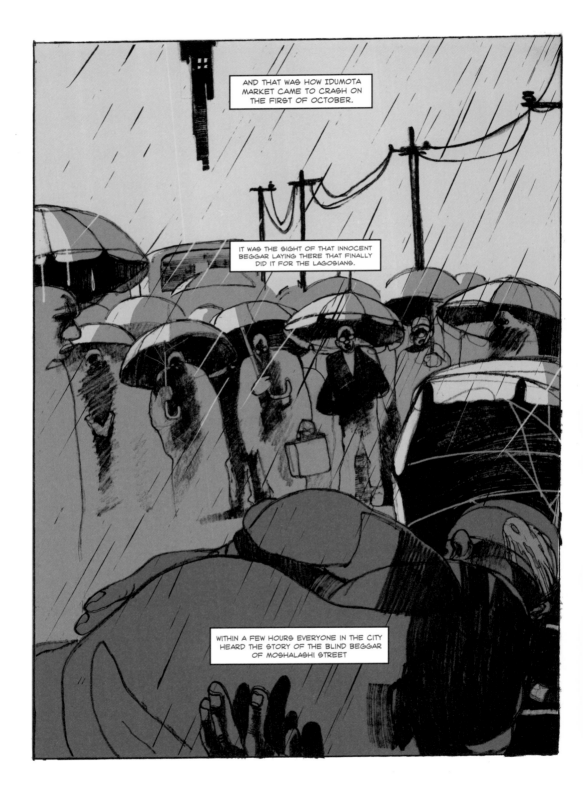

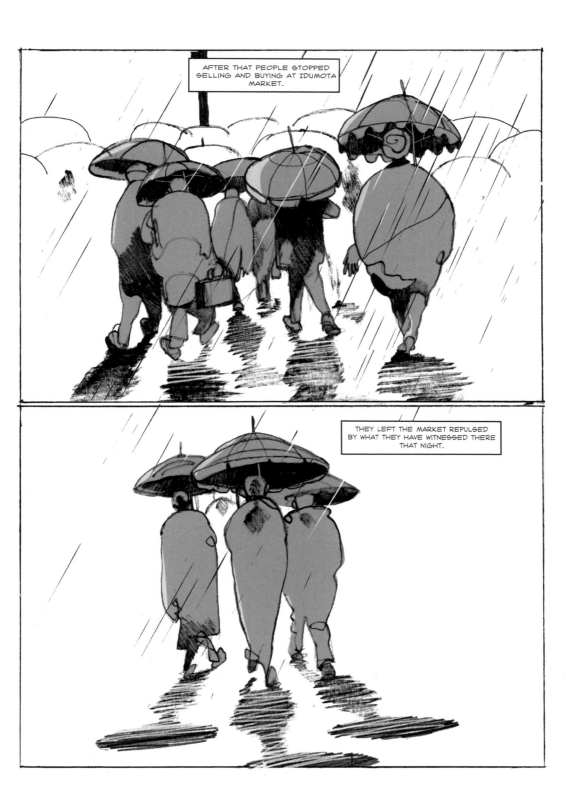

AND THE NEXT DAY-

NO ONE SHOWED UP
AT THE MARKET.

IDUMOTA MARKET FELL ON THE FIRST
OF OCTOBER. GWARIMPA FOLLOWED
SUIT A FEW DAYS LATER. THEN
KURMI MARKET CLOSED IN KANO.

AFTER THAT IT WAS PRETTY MUCH A DOMINOES
EFFECT THING, ONE AFTER ANOTHER, MARKETS
ACROSS NIGERIA WERE GOING ON A PERMANENT
STRIKE IN PROTEST OF THE IDUMOTA MARKET
SHOOTING.

A STRIKE UNLIKE THAT OF THE TEACHERS
OR THE JANITORS AS THE EFFECT IS FELT
IMMEDIATELY.

THEN REPORTS KEPT POURING IN THAT:
MARKETS ARE CLOSING ALL OVER
AFRICA.

COMMON FOLKS THROUGHOUT
THE CONTINENT WERE TELLING
THEIR LEADERS THAT:

"THE MARKET IS NO PLACE FOR
VIOLENCE"

THAT THERE IS NO TRADING WHERE
THERE IS NO JUSTICE.

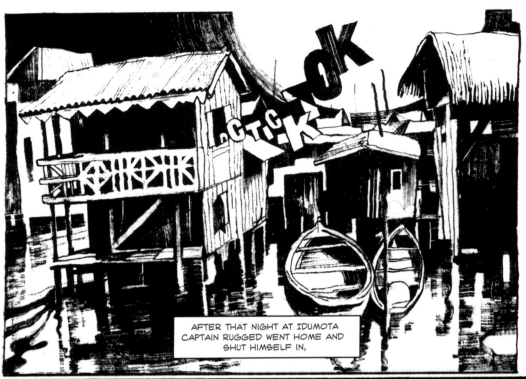

AFTER THAT NIGHT AT IDUMOTA
CAPTAIN RUGGED WENT HOME AND
SHUT HIMSELF IN,

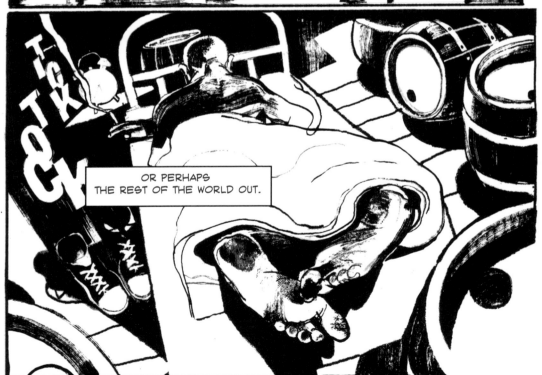

OR PERHAPS
THE REST OF THE WORLD OUT.

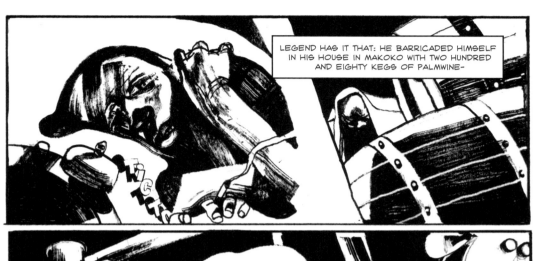

LEGEND HAS IT THAT: HE BARRICADED HIMSELF IN HIS HOUSE IN MAKOKO WITH TWO HUNDRED AND EIGHTY KEGS OF PALMWINE-

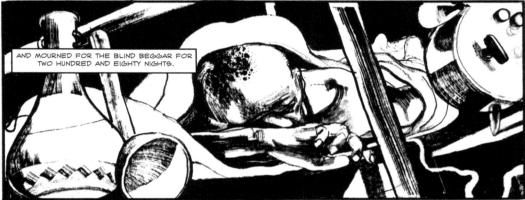

AND MOURNED FOR THE BLIND BEGGAR FOR TWO HUNDRED AND EIGHTY NIGHTS.

UNTIL EVERY LAST KEG AND GOURD WAS EMPTY.

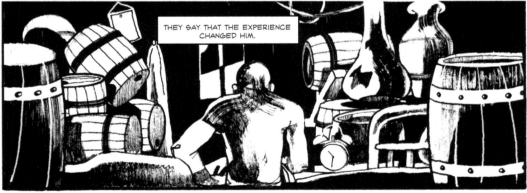

THEY SAY THAT THE EXPERIENCE CHANGED HIM.

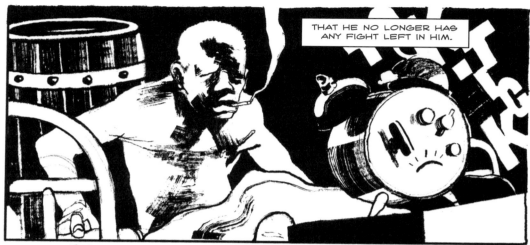

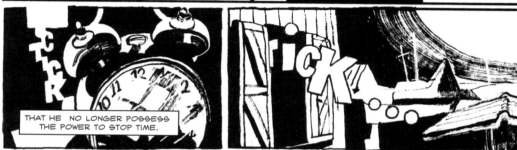

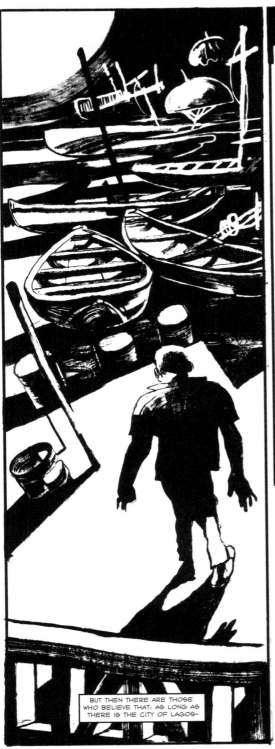

BUT THEN THERE ARE THOSE WHO BELIEVE THAT: AS LONG AS THERE IS THE CITY OF LAGOS—

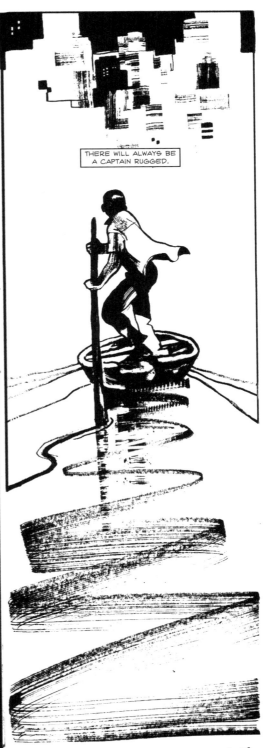

THERE WILL ALWAYS BE A CAPTAIN RUGGED.

N.M.

KEZIAH JONES

Keziah Jones is a singer songwriter and guitarist who has been creating his own unique form of music over the last 20 years.
His albums include: blufunk is a fact, african space craft, liquid sunshine, black orpheus and nigerian wood.

He is Nigerian in origin, and his music is specifically yoruba in character in terms of its dominant use of rhythm.

Lyrically he transforms the typical occidental artistic tropes of identity, sexual politics and religion by re-imagining them through the reality of contemporary Africa.

The result is what he calls *Blufunk* a musical exhibition of the modern african mind.
His latest album is called *Captain Rugged*. It was created as the soundtrack to this graphic novel you hold in your hand he hopes you enjoy it.

NATIVE MAQARI

My Name is Native Maqari. I draw.

I was born In Nigeria, Raised In Brooklyn NY, and for the past few years been working out of Paris.

My work is a continuous quest to unify and give sense to an otherwise fragmented identity scattered across three different continents.

I spent the better part of the last fifteen years traveling and filling up white pages with china ink and the experience has taught me to respect 'the blank page'.

Thanks to Kunle Tejuosho, Duro Ikujenyo, Oyewale Sanyaolu, Hauwa Mukan-Sanyaolu, Bogobiri House, all the inhabitants of Makoko and to the area boys who live under the bridges and overpasses of Lagos city.

Thanks to Because Music.

KEZIAH JONES | NATIVE MAQARI

© **Artworks**, NATIVE MAQARI
© **Text**, KEZIAH JONES and NATIVE MAQARI
© Damiani 2013

Graphic Design
François Morel

Colored by
Maxime Sabourin and Zéphir

DAMIANI
Damiani
via Zanardi, 376
40131 Bologna, Italy
t. +39 051 63 56 811
f. +39 051 63 47 188
info@damianieditore.com
www.damianieditore.com

Printed in October 2013 by Grafiche Damiani, Bologna, Italy.

ISBN 978-88-6208-340-9